RAY CAMPBELL SMITH'S
WATERCOLOUR LANDSCAPES

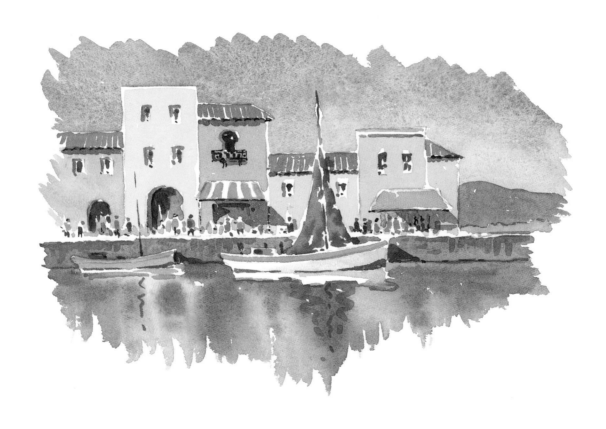

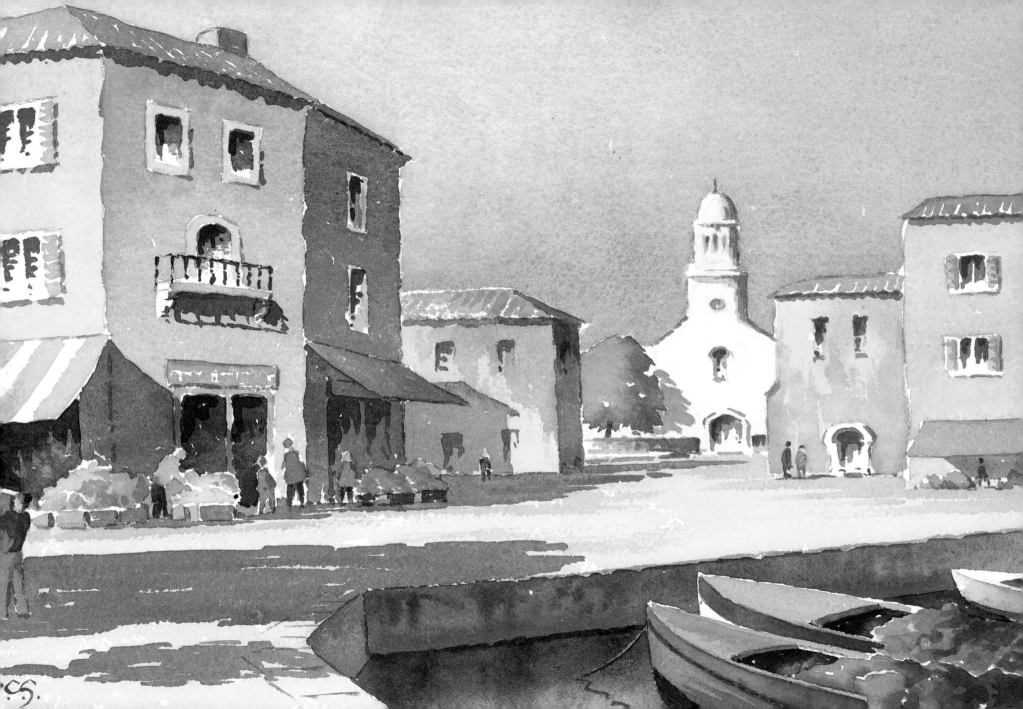

RAY CAMPBELL SMITH'S
WATERCOLOUR LANDSCAPES

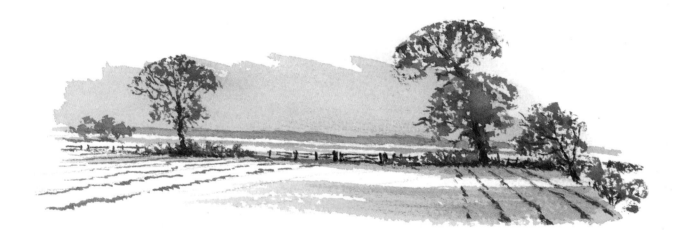

David & Charles

A DAVID & CHARLES BOOK

First published in the UK in 1997
First paperback edition 2003

Distributed in North America
by F&W Publications, Inc.
4700 East Galbraith Road
Cincinnati, OH 45236
1-800-289-0963

A catalogue record for this book is available from the British Library.

ISBN 0 7153 0648 0 hardback
ISBN 0 7153 1620 6 paperback

Printed in China by leefung-Asco Printers Ltd.
for David & Charles
Brunel House Newton Abbot Devon

Visit our website at www.davidandcharles.co.uk

David & Charles books are available from all good bookshops; alternatively you can contact our Orderline on (0)1626 334555 or write to us at FREEPOST EX2 110, David & Charles Direct, Newton Abbot, TQ12 4ZZ (no stamp required UK mainland).

CONTENTS

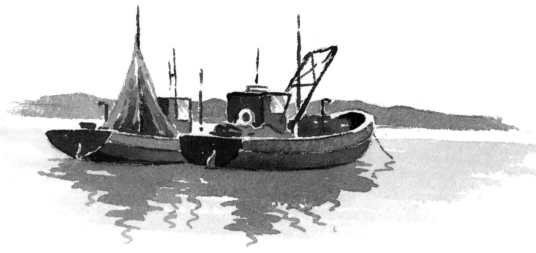

INTRODUCTION

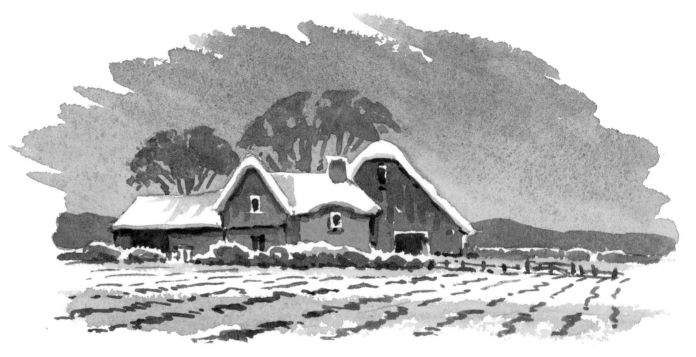

▷ *Opposite* SNOW OVER THE DOWNS

The great majority of people feel the urge to express themselves at some point in their lives, and many and various are the manifestations of this fundamental compulsion. Drawing and painting meet this creative urge in a particularly satisfying manner, for the desire to create images is innate in all of us and has its roots in our distant past. The cave paintings of our primitive ancestors show clearly that even when the struggle for existence was at its most acute, there was still a desire to look beyond the immediate and urgent demands of gaining a living.

Most children love to draw and paint, and their untutored efforts are often full of life and imagination. Sadly this enthusiasm often fails to survive years of uninspired teaching and endless attempts to portray such dull subjects as the staffroom teapot, with the result that many reach adulthood convinced that they 'cannot draw a straight line'. Even those lucky enough to have been well grounded in drawing and painting often fail to persevere after leaving school, when the demands and pressures of everyday life can leave little time or energy for the pursuit of art. Despite this, many still harbour an ambition to paint, but the gap – often a long one – since they last handled a brush has an inhibiting effect, and if their first tentative efforts are disappointing, they soon become discouraged and convince themselves that they just do not have the necessary talent. My own

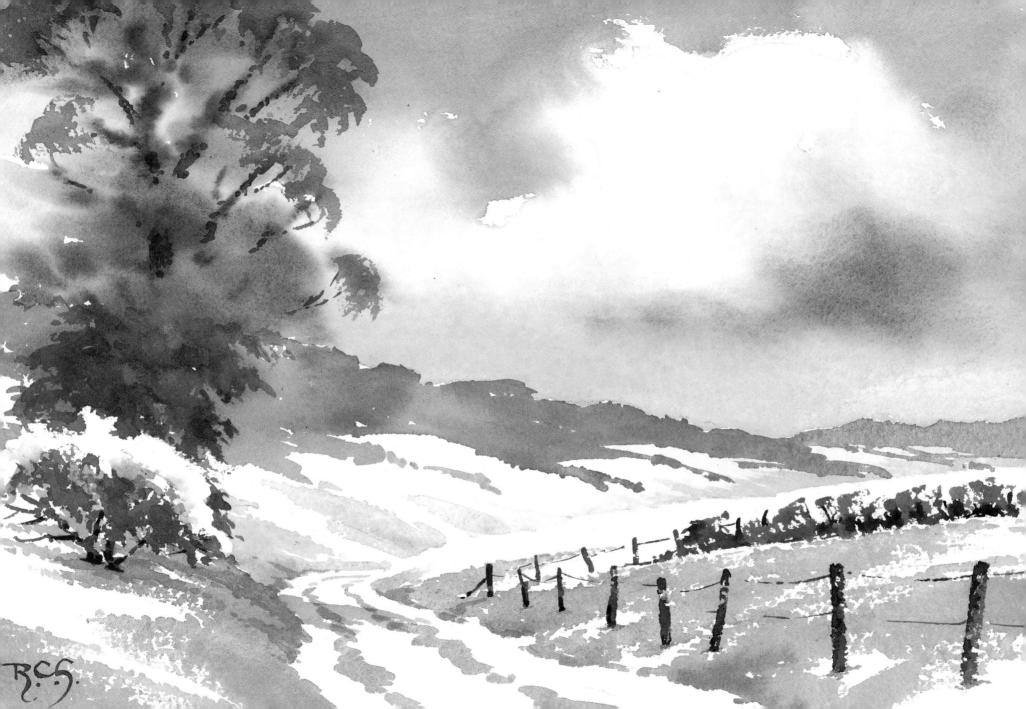

experience suggests that if the urge is there, real progress is possible if sympathetic help is at hand.

Those who love beautiful scenery and have an appreciation of line and colour are already halfway there, and all they need to set them on the right road is encouragement and help with technique. True, effort and dedication play an important part in the equation, but if hope has been rekindled, most aspiring artists are prepared to work hard, and soon find enjoyment and satisfaction along the way.

Their first main problem is that of choosing subject matter, and this is where help and advice are urgently needed. It is natural that would-be artists are drawn to subjects that appeal to them, but with little thought for the limitations of the medium, and so they often set themselves impossible tasks. Breathtaking views and grand panoramas have an understandable but fatal fascination, their very complexity and superabundance of distant detail presenting almost insurmountable difficulties.

Inexperienced painters would generally be far better advised to be less ambitious, at least in the early stages. They will then find that a small section of the vista affords a far more suitable subject, and one that will not make such heavy demands upon their limited technique. With growing experience they will begin to distinguish those subjects ideally suited to watercolour treatment from those for which the medium has less to offer.

Then there are those who are fatally attracted to the 'picturesque' and concentrate exclusively on idealised rustic idylls, often to the total exclusion of the real world all about them, a condition sometimes known as the 'thatched cottage syndrome'. Now there is nothing wrong with painting the rural scene and it is well that it should be recorded for posterity before it disappears altogether. I delight in painting the wonderful farmsteads of my native Weald of Kent and when I see what has befallen some of them at the hands of insensitive developers, I am glad to have made some record of how they used to be. What I am advocating is the cultivation of an interest in and an awareness of our surroundings, however unpromising they appear to be at first sight.

If we cultivate an open and questioning mind, we will find exciting subject matter in the most unlikely places, and will come to realise that the identity of the subject is far less important in creating a successful painting than the satisfying interplay of line, colour and composition. These elements can occur anywhere and are by no means confined to conventionally attractive subjects. Industrial wastelands and urban back streets, when tackled with imagination and insight, can inspire memorable paintings that are rich in feeling and atmosphere. So cultivate a roving eye (in a strictly artistic sense), and you will be delighted at the opportunities that open up before you.

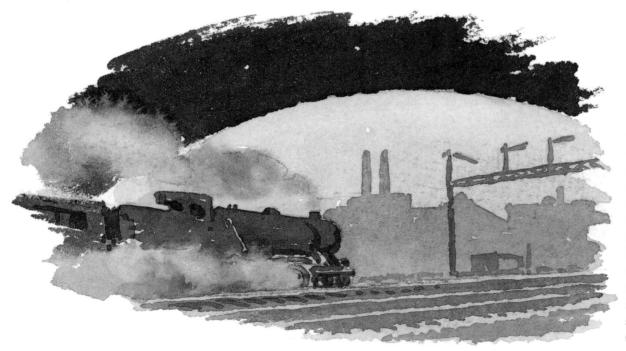

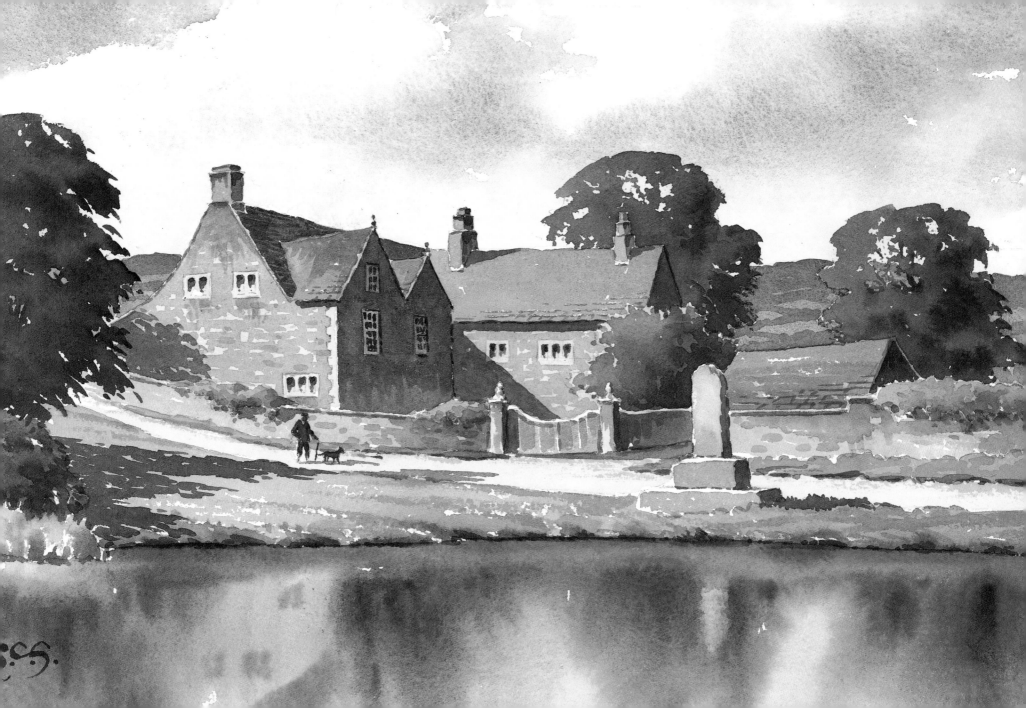

▷ *Opposite* Japanese
Garden

To develop any subject successfully, a knowledge of composition is vital. Good composition is, quite simply, the arrangement of the subject matter on the paper in such a way that the result is well balanced and pleasing to the eye. Some fortunate artists have a natural instinct for sound composition – others have to study the theory in some depth to achieve comparable results.

It always helps to have a focal point or centre of interest, and in a well composed painting some of the dominant construction lines will lead the eye towards it. Avoid any lines that lead the eye away from it or, worse still, carry the eye right off the paper. Such features as roads, tracks and rivers can help or hinder in this respect. Other things to avoid are prominent lines, such as the horizon or a church steeple, which cut the paper into two equal halves, either horizontally or vertically. Remember, too, that balance will be destroyed if

all the tonal weight of your painting is on one side. Such devices as placing a heavy cloud mass on the paler side can often restore compositional harmony. Remember, too, that conventional composition, though safe, is not always the most effective, and a more original slant can often add punch and interest

2B and 4B pencil

Pen and indian ink

Line and wash

to a painting. So, while there is no point in breaking the rules for no good reason, stretching them for added impact is quite justified and can make good sense.

Just as a poor composition can ruin a painting, however good the painting technique, so poor or inaccurate drawing can have an equally damaging

effect, and due care should be taken with such matters as perspective and proportion. At the same time, too much careful drawing can inhibit the painting process, and the detailed and precise outlining of trees and foliage, for example, will prevent you employing free and expressive brushwork, which, given free rein, would in fact do the job with much greater panache. The more experienced you become, the less drawing you will require on your watercolour paper.

A vital part of the creative process is the preliminary reconnaissance, and this should never be skimped, however keen you are to get down to the business of painting. Whenever a subject grabs your imagination, you should make sure you choose the best and most effective angle. This will involve a certain amount of exploration and also,

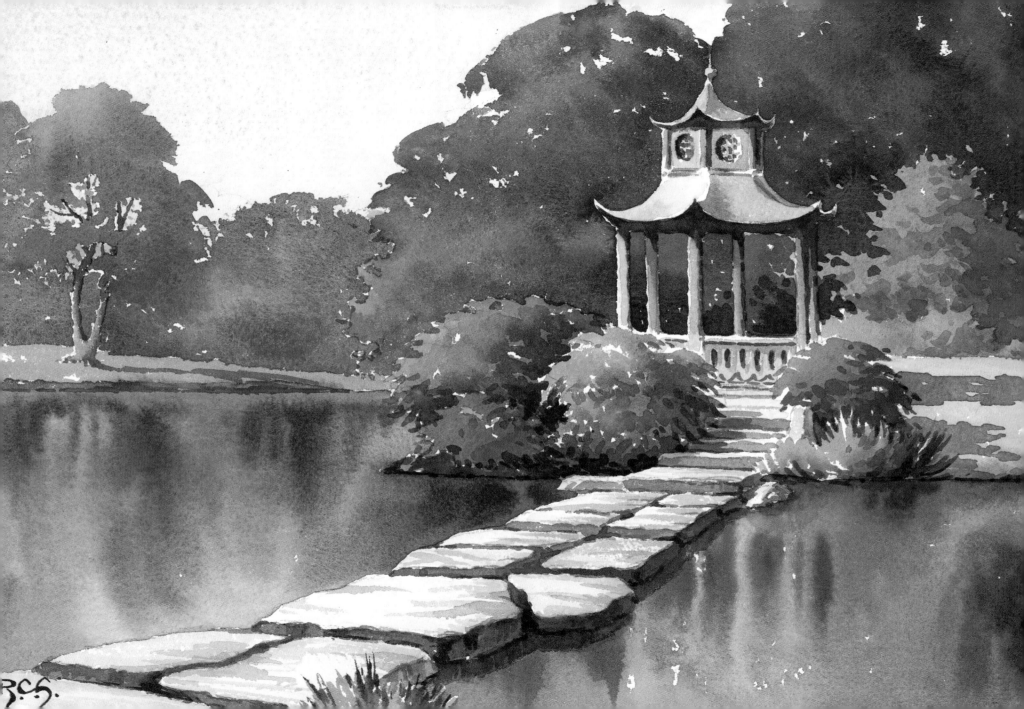

perhaps, several rough thumbnail sketches. These will probably help you decide the most telling angle to your subject, and the one you choose can then be expanded to the size of your intended painting. Never sketch directly on to your watercolour paper, for the inevitable rubbing out will damage its sensitive surface and your washes will never be as fresh and clear as they should be. Only when all the compositional and other problems have been ironed out should the image be transferred to your watercolour paper, either directly, if you are sufficiently confident, or by a tracing technique if you are not.

There are a variety of drawing implements which may be used for the preliminary rough sketches and it is a good idea to experiment with these to find out which suits you best. As well as the workaday pencil, which is familiar to everyone, there is the Conté pencil, the water-soluble pencil, charcoal and the charcoal pencil, the black crayon, pen and ink, and so on. I often use a pen and a brush and either monochrome watercolour or diluted indian ink for looser effects. The more precise tools, such as pencil or pen, are naturally more suited to subjects requiring some accuracy, while charcoal and wash, for instance, are more effective for broader images.

In the following chapters I use a range of implements, according to their suitability for the subject. It is also worth noting that the preliminary sketches reproduced in this book are considerably more finished than those I normally produce, but this is simply to make the image clearer and more useful in printed reproduction.

Let us now assume you have chosen a promising subject, have decided upon the most attractive aspect, produced a well composed sketch and transferred the essential lines of this sketch to your watercolour paper. What is the next step? What you should *not* do is begin to apply paint immediately, for if you omit the essential stage of thinking and planning ahead, your results are quite likely to be wrong in tone or colour (or both). You will then be forced to make alterations and modifications which will really mean the end of

freshness and clarity in your washes. The true beauty of watercolour lies in this freshness and clarity, and once they are lost, through alteration, overworking, or the mixing of too many colours, muddiness rears its ugly head and the attraction of the medium is then lost for ever. Successful washes are those that are applied quickly and loosely and then left alone. Any attempt to alter or vary them once they are on the paper means a progressive loss of transparency, so it behoves us to ensure that they are right in tone and colour. This

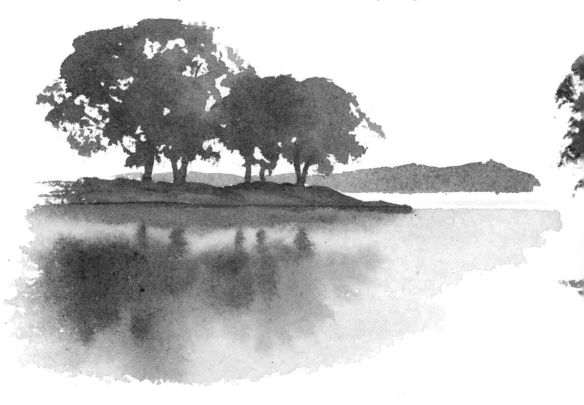

may mean trying them out first on an offcut of similar paper; however, as you gain in experience, you will be able to judge the suitability of your washes from their appearance on the mixing palette. Whatever you do, avoid experimenting on your watercolour paper and always plan your next step in advance. Work out in your mind how the various passages in your subject are to be treated, and, if necessary, try out this treatment in rough. If it works, well and good – it is then safe to proceed. If it does not, some alternative approach must be tried.

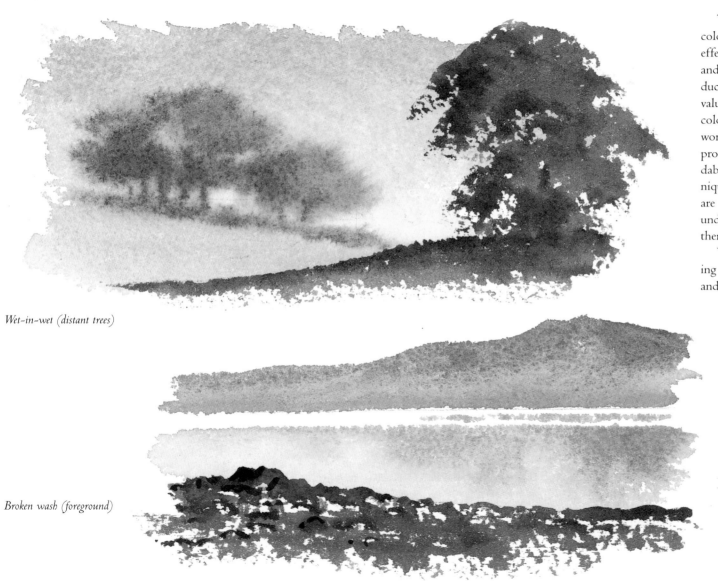

Wet-in-wet (distant trees)

Broken wash (foreground)

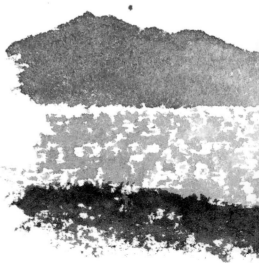

There are all sorts of techniques in water-colour painting and these can be used to good effect to portray many different kinds of materials and textures. The wet-in-wet technique can produce soft, misty and mysterious effects, and it is a valuable weapon in the armoury of the water-colourist. Moreover broken washes and dry brush-work can convey a wide variety of textures and produce a far more painterly effect than repeated dabs with the point of a small brush. These techniques are used extensively in the paintings which are reproduced on the following pages, and it will undoubtedly aid your own work greatly if you add them to your own painting repertoire.

You can obtain more vivid effects by employing tonal contrast (placing lights against darks) and colour contrast (placing complementary or

opposite colours side by side). You should always be on the lookout for such effects and then do them full justice, even exaggerating them if necessary. Never be afraid to modify the scene in front of you to obtain a better composition and a painting with more impact. Moving a dark tree to a position behind a sunlit roof to obtain a strong tonal contrast, or introducing a red figure into a predominantly green landscape are just two examples of this sort of manipulation. If you are carrying out a commission to paint someone's house or home town, you naturally have to be more accurate, but even then there are things you can do to achieve a livelier result. Delaying making your sketch until the sun is in a position to produce more interesting shadows is an example of patience paying off.

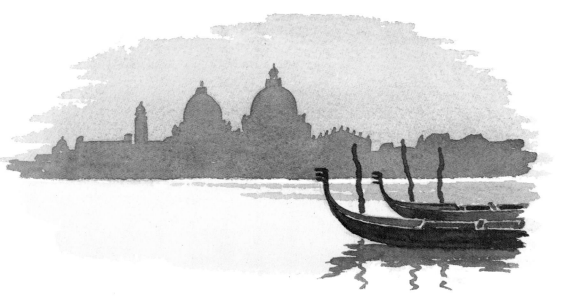

Flat wash (distant buildings)

Dry brushwork (near tree trunks)

Broken wash (water)

The question often arises as to whether or not to include a figure in the landscape. On the one hand a well placed figure can provide a useful focal point and add human interest. On the other, a figure would be out of place in a painting of, for example, a remote Scottish loch, in which the aim was to convey a feeling of brooding loneliness. Sadly, figures are often absent from paintings in which they might well have served a useful purpose, for no better reason than the artist's inability to tackle them convincingly. It is true that a badly executed and wooden-looking figure generally does far more harm than good, but with observation and practice most painters can improve their figurework to an acceptable standard provided they concentrate on posture rather than detail. The chances of finding the perfect model in the right place at the right time are remote, but a well stocked sketch book should be able to provide something suitable.

In each double spread in the following chapters, the left page contains my preliminary sketch and my description of how I developed the subject or tried to overcome some of the problems which arose. The finished painting appears on the right. I hope the study of this process will help you bridge the awkward gap between recognising an appealing subject, and then developing it into a satisfying and compelling painting.

▷ *Opposite* Beech
Trees

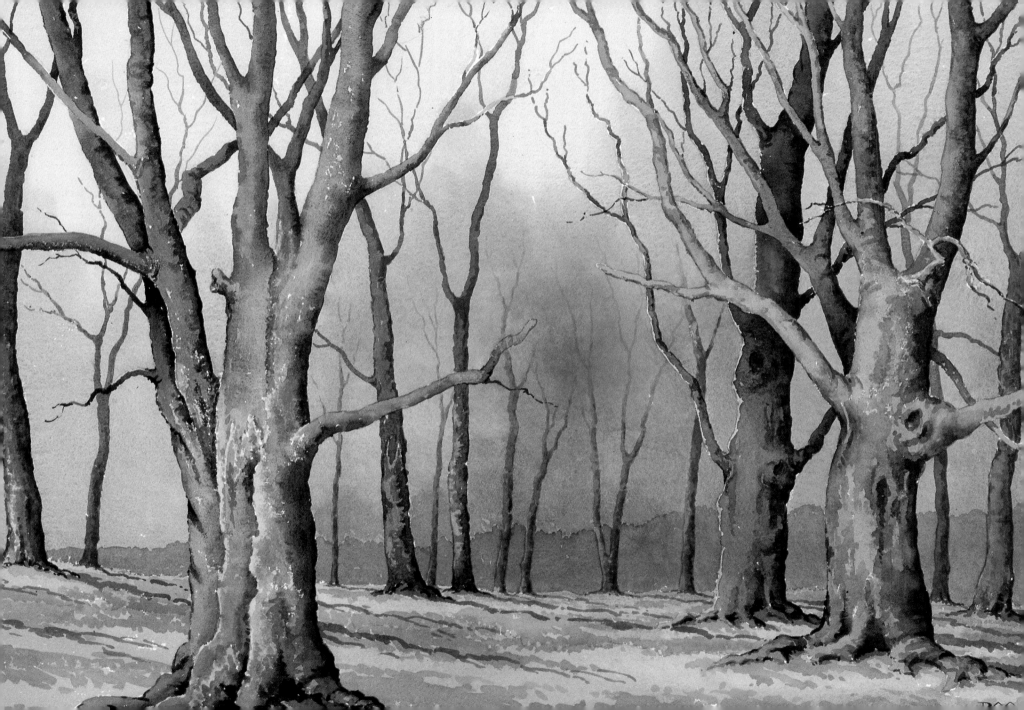

SEASHORE AND HARBOURSIDE

The immense variety of coastal scenery around the shoreline stems directly from the nature of the rock that forms the margin of the land mass. Hard old rocks such as granite give rise to rugged and often spectacular shorelines, while the softer sedimentaries produce gentler, less dramatic scenery. Land relief also plays an important part; where hills meet the sea, towering cliffs result, but where the land is lower, the margin is often marked by little more than sand dunes.

The coastal scenery is uniquely suited to the fluid watercolour approach, with broad washes capturing such passages as expanses of wet, reflective sand and stretches of smooth water. The sky is a dominant influence in all types of marine painting and should be handled boldly and freshly.

In developed countries the coastline is, for good or ill, greatly affected by man's activities. The older fishing villages and harbours, largely built of local stone, almost seem to be an extension of the natural landscape and are a delight to paint. Fishermen's huts and boatyards are also a rich source of subject matter. Boats, with their subtle curves, need careful handling, and if incorrectly drawn, may look thoroughly unseaworthy.

I have included a variety of marine subjects in the following pages and hope some of the paintings may kindle your interest in the fascinating possibilities of the coastal scene.

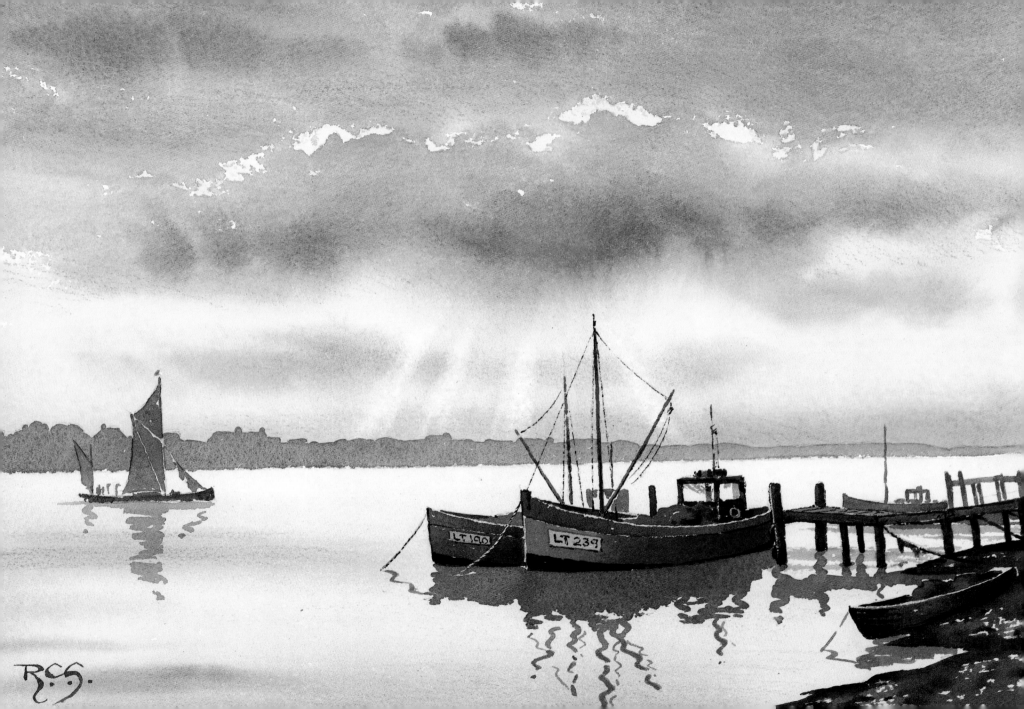

BEACHED FISHING BOATS

PALETTE

RAW SIENNA
BURNT SIENNA
LIGHT RED
FRENCH ULTRAMARINE
PAYNE'S GREY

PAPER

ARCHES 300LB (640GSM)
ROUGH

BRUSHES

THREE 1IN (2.5CM) FLATS
NO.12 AND NO.6 SABLES

Brush and ivory black

Craft of all types make fascinating subjects for the painter, and these fishing boats, drawn up on the shingle of Dungeness, Kent, make a dramatic statement against a patch of luminous sky. It was a lively, cloudy sky and I placed some heavy cloud shadow on the left of the painting to help balance the main weight of the composition – the boats and shingle – on the right.

I used a pale wash of raw sienna for the lighter areas of sky, dilute Payne's grey for the softer cloud shadows, and a wash of french ultramarine and light red for the heavier cloud formations on the left. These washes were each applied in swift succession and allowed to merge. I determined to keep the treatment of the sea as simple as possible and so made a feature of the nearest wave, merely suggesting the more distant breakers by leaving rough lines of white paper when applying the wash. The foam-streaked stretch of shallow foreground water was treated in a similar fashion. I used raw sienna with a little Payne's grey for the sea, and french ultramarine with a touch of light red for the cloud-shadowed expanse towards the horizon. I then made sure that the patch of wet sand left by the last receding wave, reflected the tones and colours of the sky above.

The white gaps in the loose, broken wash suggest breakers in the choppy sea

The fishing boats and the shingly foreground were painted in deep tones to ensure they registered strongly against the shining sky behind. The tide-lines of seaweed in the centre foreground give form to the foreshore and, with the lines of the waves, direct the eye towards the fishing boats.

MAKE THE MOST OF STRONG TONAL CONTRASTS TO ADD DRAMA TO YOUR PAINTING

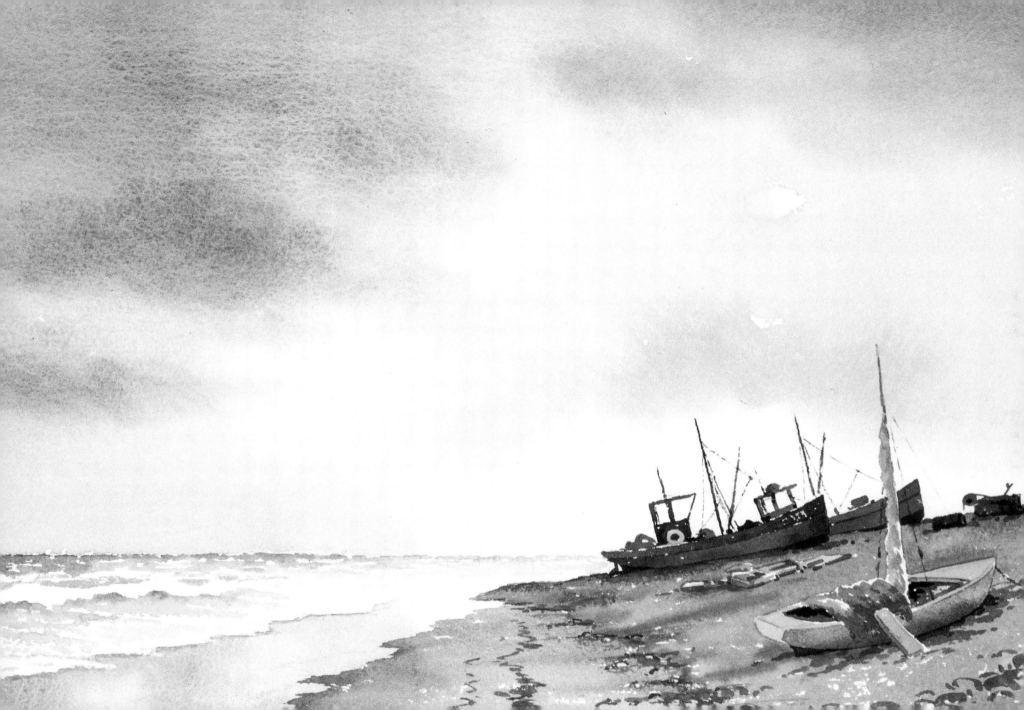

SCOTTISH FISHING PORT

This scene is typical of the many small villages which dot the coastline of Scotland. The group of sturdy fishing boats, backed by a jumble of fishermen's cottages in all sizes, shapes and colours, makes an attractive subject for the water-colourist to paint.

With a busy scene like this occupying most of the paper, the sky needs little emphasis; I used a pale wash of french ultramarine to outline the summery clouds and a still paler wash of raw sienna to indicate the warm-coloured area below.

The cottage walls are flat washes of creams, pinks and greys and I made sure to give full value to the warm, reflected light on some of the shadowed elevations. Quick brush strokes of light red and burnt sienna follow the slopes of the roofs to suggest the warm-coloured pantiles, while the figures on the quayside provide the painting with a touch of human interest.

The fishing boats in the foreground are more strongly painted so they stand out from the background scene, and I also made a point of indicating

Although the reflections are strongly painted, the colours within them are soft-edged

the cast shadows equally strongly. The sea wall is a variegated wash of brown, merging into green near the water line to represent seaweed and marine algae, and I added a few random blocks of similar colours. The water should provide a more restful passage and although the reflections in the ripples are strongly outlined, the colours in them are soft-edged and merge together.

2B pencil

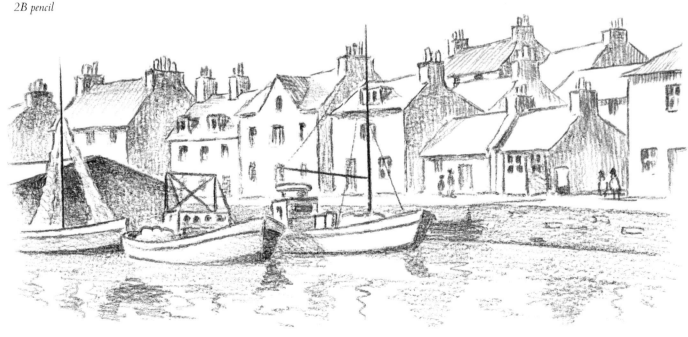

WHEN A BUSY SCENE OCCUPIES MOST OF THE PAPER, THE SKY SHOULD BE UNDERSTATED TO AVOID COMPETITION

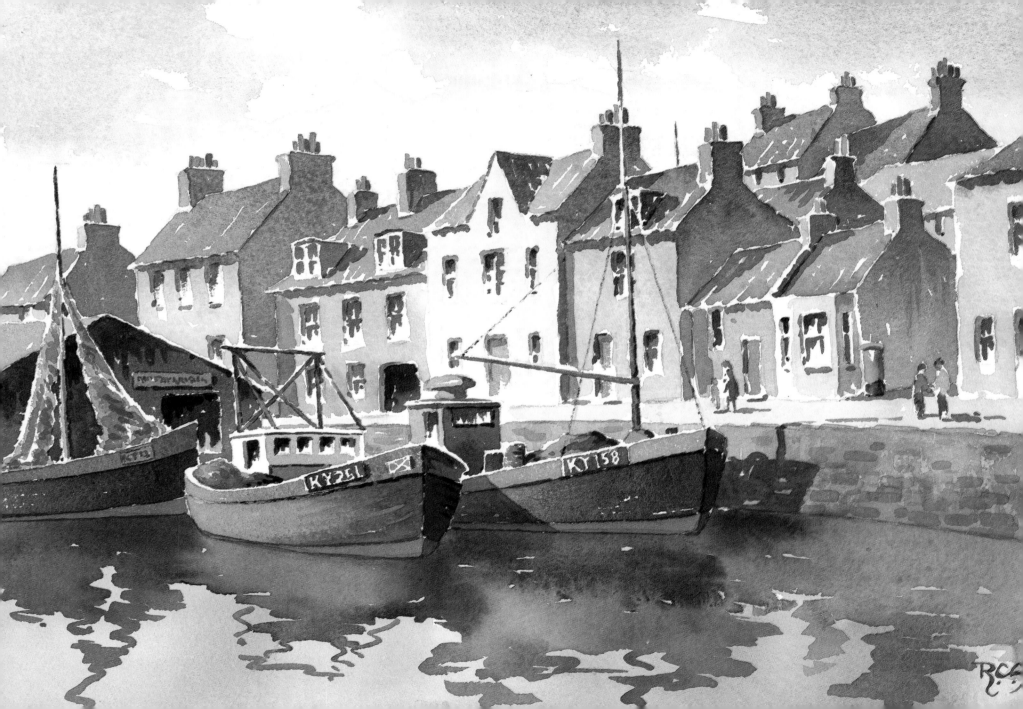

EVENING BEACH RIDE

The glow of a summer's evening reflected in the wet sand of the ebbing tide was a most appealing subject, but totally lacking a centre of interest or focal point. While I was pondering whether to introduce a beached boat or a man walking his dog in the foreground, three riders came cantering along the foreshore and instantly solved my problem.

After making a lightning sketch of the riders, I laid down a variegated wash over the whole sky area – raw sienna with the merest touch of Winsor blue at the top shading into raw sienna and light red, and ending with light red and french ultramarine just above the horizon. While the paper was still wet I dropped in a mixture of the last two colours to take care of the soft-edged clouds.

The light red separated a little as it very often does in liquid washes, to produce the hint of a warm halo around the edges of the cloud.

I painted the sea in raw sienna with a touch of Winsor blue, adding the pale cloud shadows and the stronger lines of foreground waves, leaving gaps to accommodate the riders. The wet sand reflected the colours of the sky and the deep tones of the foreground shingle made it shine by

Brush, pen and indian ink

contrast. A broken wash of french ultramarine and light red over the rough paper suggested this shingly surface. The three riders went in last with some care but little detail.

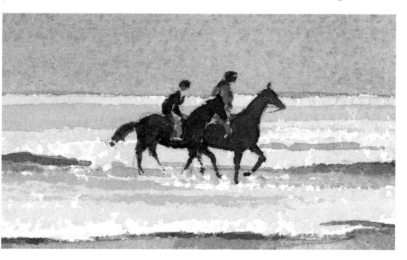

The deep tones of the riders register in strong contrast against the pale background

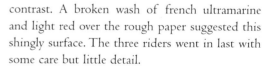

MAKE SURE THAT ANY MOVING OBJECTS
(THE HORSES IN THIS CASE) CARRY THE EYE
INTO THE PAINTING AND NOT OUT OF IT

PALETTE

RAW SIENNA
BURNT SIENNA
LIGHT RED
FRENCH ULTRAMARINE
WINSOR BLUE

PAPER

ARCHES 300LB (640GSM)
ROUGH

BRUSHES

TWO IIN (2.5CM) FLATS
NO.10 AND NO.6 SABLES

CORNISH HARBOUR

The many little harbours around the rugged coastline of Cornwall have a fascination of their own and it is not surprising that the county has long been a Mecca for artists. The Newlyn School (which flourished at the end of the nineteenth century) springs to mind and the work of that talented group is still much admired.

One of the questions that always arises in scenes such as this concerns detail. How much should we include, how much should we omit? With complex subjects, some simplification is

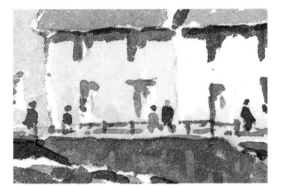

The figures are little more than dots of paint, but they do suggest human activity

essential, but lose too much detail and some of the character can be lost. In this scene, I limited the number of boats to avoid over-complicating the foreground, and represented the distant shore with a single flat wash of blue-grey, with three tiny triangles left unpainted to represent white sails. In similar fashion, the more distant houses are shown as a single wash of grey with a little warmer colour dropped in.

Many inexperienced painters have difficulty with boat shapes, with their lines curving in two planes. Some teachers recommend constructing their outlines within coffin-shaped boxes which can be drawn more easily in perspective, and this may help — but as with so much in art, the best way is through careful observation and practice.

Here the sky is mainly broken cloud, with the light coming from the left. Most of the cottage walls are whitewashed but a few are red brick or cement rendered, and the shadows are all strongly indicated. Putting in a van and a few tiny figures adds a touch of life.

2B and 4B pencils

In A COMPLEX SCENE, MAKE A CONSCIOUS EFFORT TO SIMPLIFY WHENEVER YOU CAN

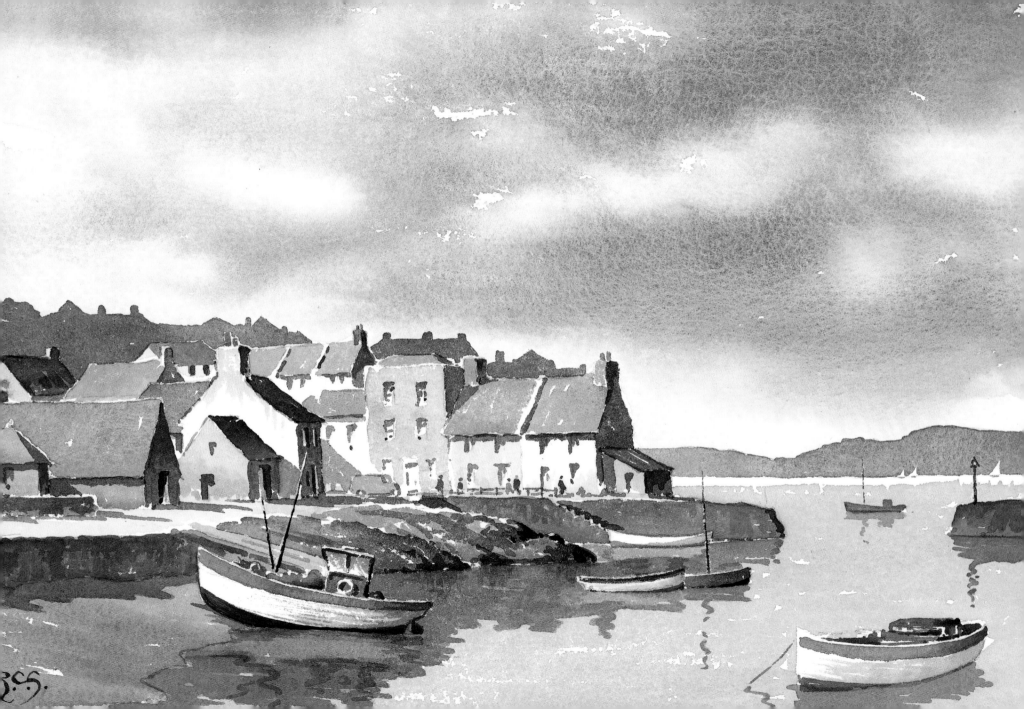

FISHING BOATS AT ANCHOR

In this painting the harbourside buildings and the shoreline are very loosely painted and are pushed well into the background. Only the foreground boats, the harbour wall and the figures are dealt with at all strongly.

I began by covering the whole paper with a variegated wash. The first component of this wash was french ultramarine with the merest touch of light red, and the second was just raw sienna. I started applying the first liquid mixture with horizontal strokes of a 1in (2.5cm) flat brush at the top of the paper. About a quarter of the way down I started dipping the same brush into the second liquid mix, and then, about three-quarters of the way down the paper, started dipping it again in the first mix. The result was a gradual soft transition from pale blue-grey at the top, through pale green, pale yellow, back to pale green and finally pale blue-grey at the bottom of the paper. I let everything dry, and then began painting in very loosely the roofs, windows and the shadowed elevations of the distant buildings in pale greys. I then added a wash of slightly deeper grey to represent the line of hills behind. The distant boats went in next and then the soft reflections in colours corresponding to the object above.

The nearer boats, the harbour wall and the figures were painted in stronger tones when the

Brush, pen and indian ink

paper was again quite dry. There is little detail in the figures, but I took care with posture. Then I added the near reflections in strong tones and these produced a lively effect against the pale water.

Attention to posture will make figures much more convincing

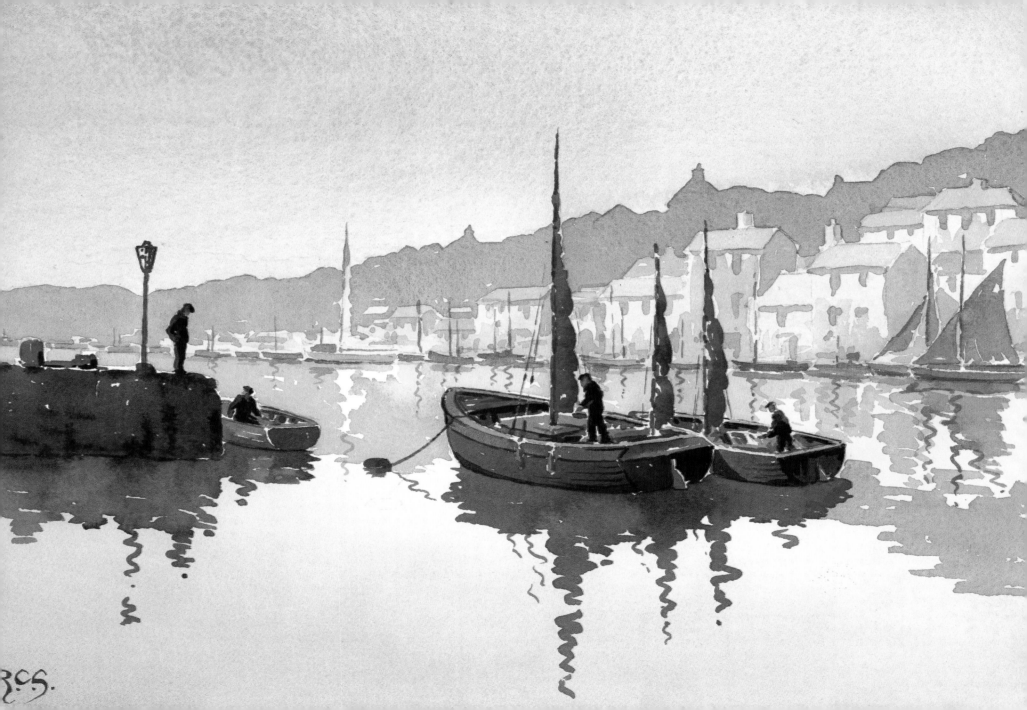

PALETTE

RAW SIENNA
BURNT SIENNA
LIGHT RED
FRENCH ULTRAMARINE
WINSOR BLUE
CADMIUM RED
CADMIUM YELLOW
VERIDIAN

PAPER

ARCHES 300LB (640GSM)
ROUGH

BRUSHES

1IN (2.5CM) FLAT
NO.12 AND NO.6 SABLES

SEASIDE

Children playing about on the beach somehow typify the English seaside holiday and make an appealing, if fleeting, subject for the painter. Quick, on-the-spot sketches are probably the best way to capture posture and movement and can be arranged later to form a balanced composition. With the accent on the figures of the children I felt the background should be treated very simply so as not to compete for attention. The sky was therefore just a pale, variegated wash, french ultramarine at the top merging into raw sienna at the horizon, slightly lighter on the left, towards the

Karisma water-soluble pencil

source of light. If you have difficulty achieving a smooth effect and end up with a hint of stripiness, it helps to dampen the paper first, but if you do this, your washes need to be a little stronger to compensate for the extra moisture.

The distant headland was just a flat wash of french ultramarine and light red, and the sea a mixture of Winsor blue and raw sienna, with the proportion of raw sienna increasing towards the water's edge. Irregular lines of white paper were left unpainted so as to suggest breaking waves, and a little shadow was added to give them form. The sand, too, was handled in a very simple way, using

The deep skin tones contrast with the pale background

a minimum of texturing to achieve the desired effect.

The children's skin tones looked surprisingly dark against the pale background and needed burnt sienna, light red and some french ultramarine for the deeper shadows. The cast shadows also required deep tones to emphasise the strength of the sun. Bright colours were needed for the children's clothes, spades and buckets.

DEEP-TONED SHADOWS HELP TO EMPHASISE THE STRENGTH OF THE SUN

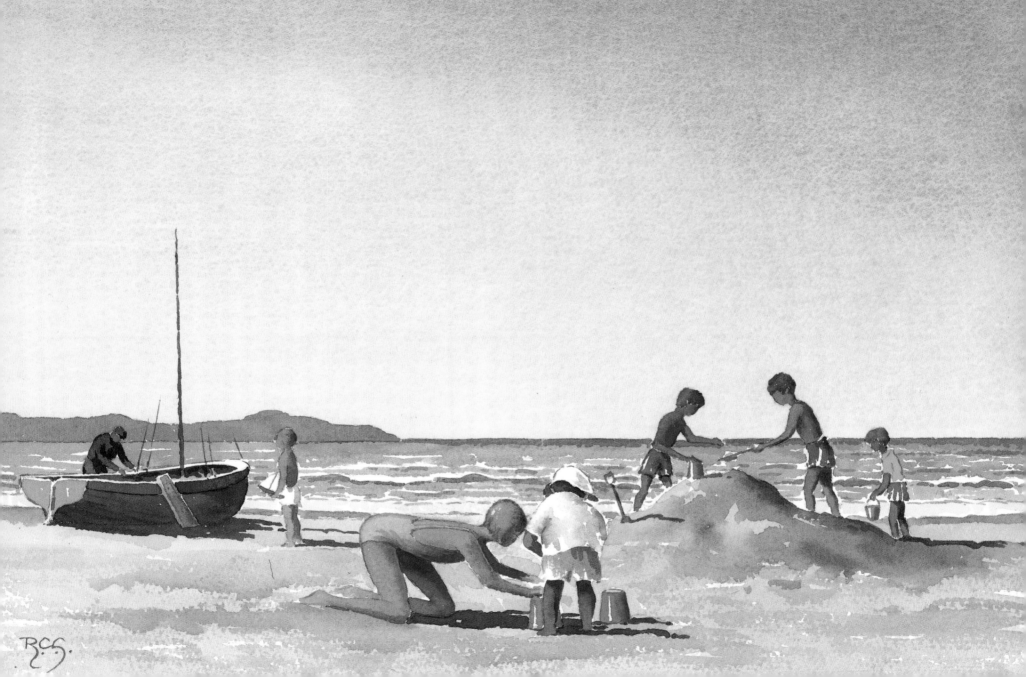

PALETTE

RAW SIENNA
BURNT SIENNA
LIGHT RED
FRENCH ULTRAMARINE
WINSOR BLUE

PAPER

ARCHES 300LB (640GSM)
ROUGH

BRUSHES

THREE 1IN (2.5CM) FLATS
NO.10 AND NO.6 SABLES

SAILING BARGES AT ANCHOR

These splendid old spritsail barges plied their trade as carriers in large numbers round the coasts and rivers of the United Kingdom well into the twentieth century. With their surprisingly shallow draught and their retractable keels they could navigate shallow waters and sail far up river estuaries. They were cheap to run, relying as they did on wind power, and were normally crewed by one man and a boy. A number are still preserved by enthusiasts and can be seen in all their glory at such places as Pin Mill on the Suffolk coast. With their russet sails and their characteristic shapes they have long been a gift to marine artists.

Brush and ivory black

The two figures in the rowing boat add a touch of human interest

My object in this painting was to make the two moored sailing barges stand out boldly against the pale background of sky and water, and to make a feature of their strong reflections. Consequently I painted the sky with pale washes (of raw sienna, french ultramarine and light red in various proportions). The water of the estuary was also raw sienna plus a touch of Winsor blue to capture its local colour and I dropped in two or three horizontal brush strokes in grey, wet-in-wet, to suggest soft-edged foreground ripples.

The barges, the hut and the foreground boat were painted in deeper colours in combinations of light red, burnt sienna and french ultramarine. The reflections were then added in slightly paler tones, with the addition of a little green. The shingle in the foreground was a broken wash to which I added the outlines of a few pebbles while the wash was drying.

> THE OLD ADAGE THAT LIGHT OBJECTS ARE REFLECTED DARKER, AND THAT DARK OBJECTS ARE REFLECTED LIGHTER HOLDS GOOD MOST OF THE TIME

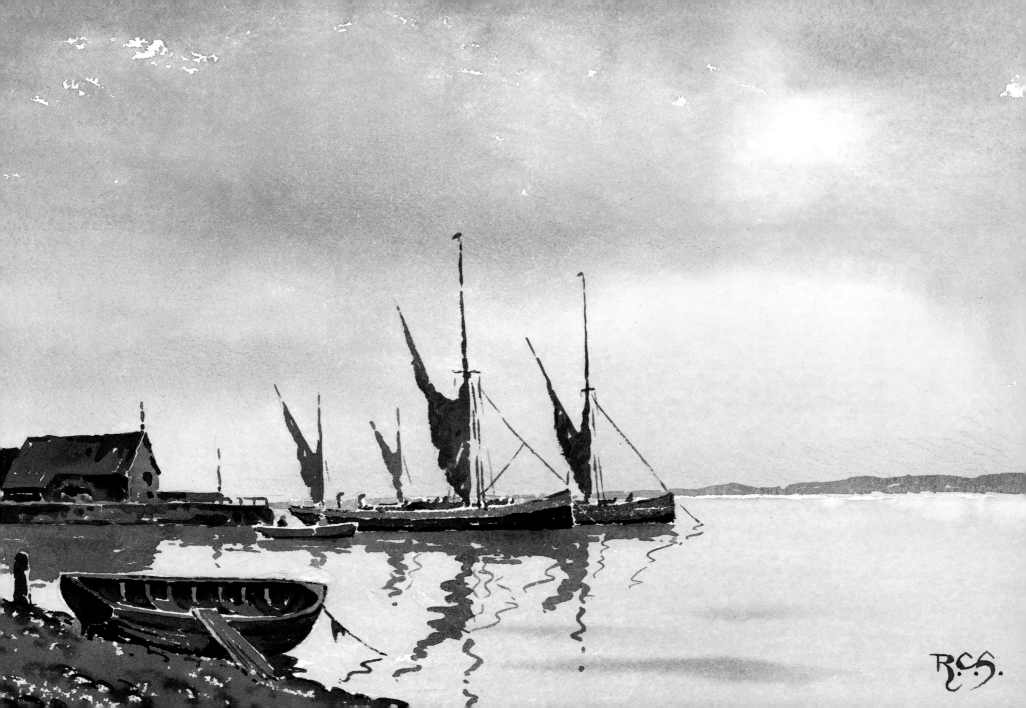

PALETTE

RAW SIENNA
BURNT SIENNA
LIGHT RED
FRENCH ULTRAMARINE
WINSOR BLUE

PAPER

ARCHES 300LB (640GSM)
ROUGH

BRUSHES

1IN (2.5CM) AND ½IN
(1.3CM) FLATS
NO.10 AND NO.6 SABLES

EYEMOUTH HARBOUR

In this fishing port on the east coast of Scotland the solid old working boats still greatly outnumber the modern pleasure craft and I took pleasure in featuring them in this painting. The odd shapes of the fishermen's cottages, with their variety of colours and textures, made an attractive background while the moored boats provided foreground interest, with those on the lower right helping to provide compositional balance. Dusk was approaching and a warm evening light suffused the scene.

In a situation such as this it often pays to apply a warm-toned wash to the entire paper to ensure that the light from the sky influences every part of the painting. Another approach might be to use

one of the modern tinted papers which, unlike some of the older varieties, are subtle and restrained in colour. Here I simply painted in the sky area with a wash of raw sienna tinged with light red and dropped in the grey clouds (french ultramarine and light red) with a wet-in-wet technique. In this way I was able to preserve the crisp white end walls of two cottages more effectively.

As the light was coming from the right, I made the sky and its reflection in the waters of the harbour somewhat lighter in tone on that side and this gave me the opportunity to introduce effective contrast with the deep-toned boats below. Although the water was smooth, the reflections were very diffuse and I have done little more than

The deep tones of the masts, spars and rigging contrast most effectively with the pale water beyond

suggest them; at the same time pale, horizontal brush strokes add some interest to the surface and help it to lie flat.

Karisma water-soluble pencil

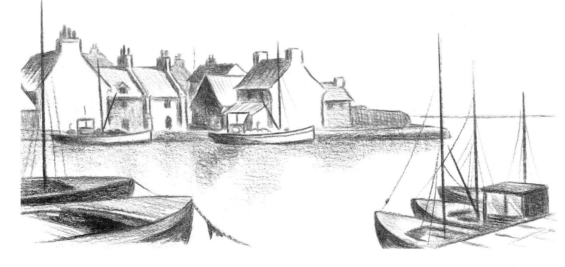

NEVER LOSE SIGHT OF THE DIRECTION FROM WHICH THE LIGHT IS COMING AND ENSURE YOUR SHADOWS ARE CONSISTENT WITH IT

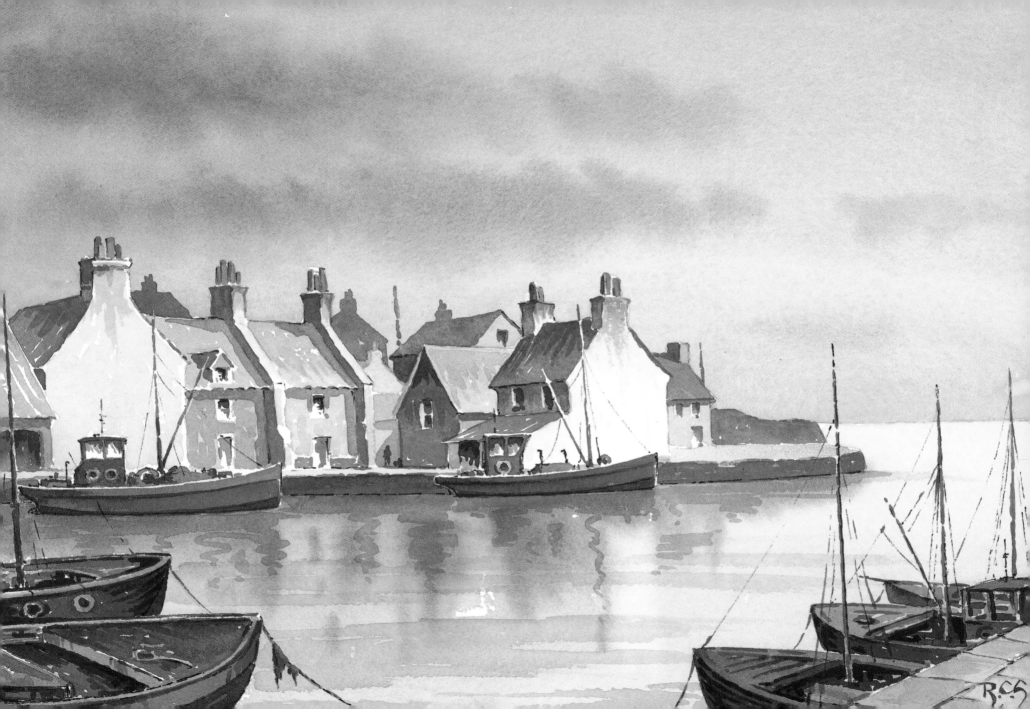

TOWNSCAPES

*I*n many people's minds the only urban subjects worth painting are the obvious ones and the tourist attractions — the famous bridges, palaces and cathedrals. While these have undoubted attractions and have inspired many famous paintings over the years, we should not shut our eyes to the appeal of humbler subjects. I have long been attracted by the possibilities of the drabber suburbs and run-down inner city areas, which in the right atmospheric conditions have a unique appeal of their own. When daylight is fading and lights begin to appear in house and shop windows, the scene is transformed. If the lights are reflected in wet road and pavement surfaces, the effect is greatly enhanced. In foggy or misty conditions, halos may appear round the street lights and may well add a subtle note.

The presence of water can add an extra dimension to the urban landscape. The matchless canals of Venice are a notable example but the rivers of large cities also play an important part. When they reflect a warm evening light, they serve the useful function of binding land and sky together.

In the following pages I have included urban street, river and canal scenes from a variety of countries as well as a few impressions of less celebrated districts. Perhaps these may tempt you to seek out your own off-beat subjects.

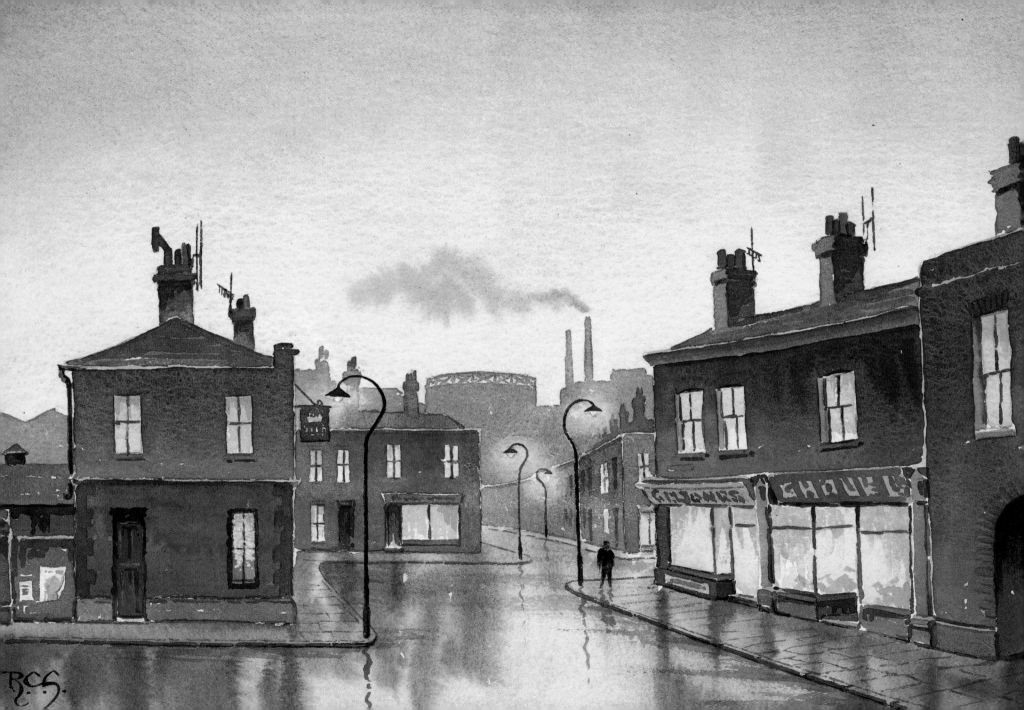

THE RAILWAY BRIDGE

PALETTE

RAW SIENNA
LIGHT RED
FRENCH ULTRAMARINE

PAPER

ARCHES 300LB (640GSM)
ROUGH

BRUSHES

1IN (2.5CM) FLAT
NO.10 AND NO.6 SABLES

This is a second attempt at a scene I first painted some years ago when I tried to capture something of the brown murk of an old-fashioned London fog. Since then smokeless zones and fuels have been introduced and such colour is a thing of the past. Here the wet road, the umbrellas and the general treatment all suggest a misty, drizzly evening, with lighted windows striking a more cheerful, contrasting note.

The composition is an unusual one, with an interesting interplay of verticals and diagonals, and lights and darks forming a strong, satisfying pattern. The building on the left prevents the road carrying the eye off the paper, and the simply treated figures and the car are mostly moving into the painting.

Counterchange plays an important part in a painting of this sort and care has to be taken to place lights against darks whenever possible and to preserve the pale areas, such as the lighted windows. The halo effect around the street lights needs careful handling. The lights themselves were preserved with masking fluid and the halo effect achieved by progressively adding water to the

Notice the halo effect around the street lights

background washes as they approached the lights.

The sky was a pale wash of raw sienna and light red, with just a touch of french ultramarine, and this warm colour influences the rest of the painting. The same colours were used in varying proportions and in deeper tones for the buildings and the reflections in the wet road. There is some, but not too much, indication of the brickwork of the buildings and the pavement flagstones.

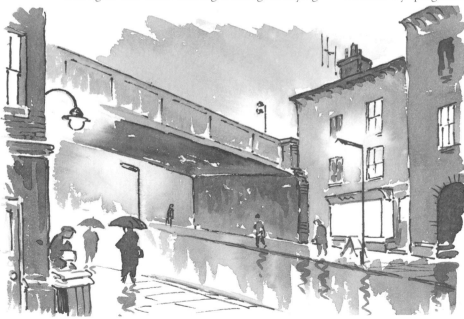

Pen, brush and indian ink

TRY TO PLAN YOUR PAINTING SO THAT IT HAS A PLEASING PATTERN OF LIGHTS AND DARKS

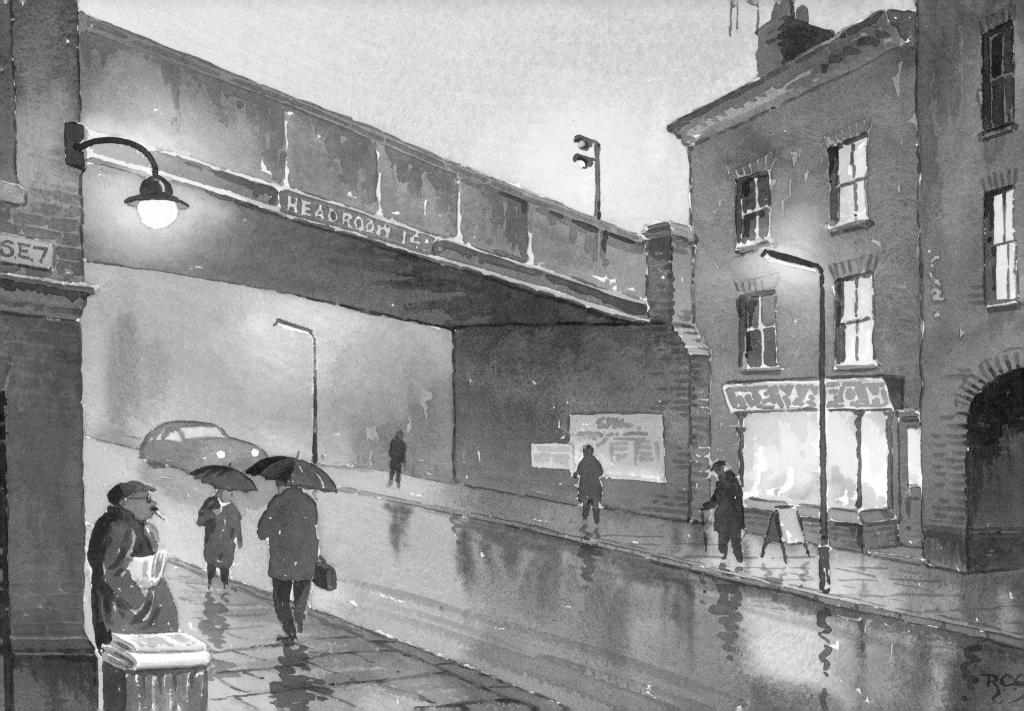

PALETTE

RAW SIENNA
LIGHT RED
FRENCH ULTRAMARINE

PAPER

ARCHES 300LB (640GSM)
ROUGH

BRUSHES

TWO 1IN (2.5CM) FLATS
NO.10 AND NO.8 SABLES

The warm grey for the smoke of the tug was applied wet-in-wet to achieve the soft-edged effect

TOWER BRIDGE, EVENING

Sunsets are subjects that should be handled with care and discretion, especially the more lurid ones that seem to contain every colour in the rainbow. They can so easily look either garish or chocolate-boxy in watercolour. It is usually wiser to keep to the more restrained skies, and preferably those with just one or two dominant colours. In this view of Tower Bridge from the Pool of London, the evening sky is mostly a pale orange with warm grey bands of soft-edged cloud. The water of the estuary appears paler than the sky above, a phenomenon that is hard to explain but frequently occurs.

The centre of interest is, of course, Tower Bridge itself which stands out boldly against its

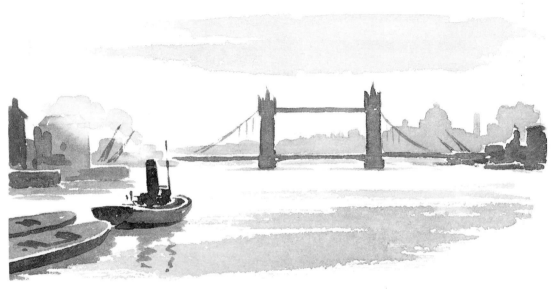

Brush and ivory black

background. It is off centre to the right and is balanced by the tugboat and its attendant barges on the left. Notice how they are heading for the bridge and so direct the eye towards it. The buildings on either bank are dealt with very simply and are somewhat understated in order to give more prominence to the expanse of water and to emphasise the feeling of space.

The line of distant buildings, which includes such landmarks as St Paul's Cathedral and the Monument, is a single pale wash of french ultramarine and light red, and these two colours, in varying proportions and deeper tones, are used for the nearer buildings and the bridge. The tug is painted still more strongly and it is this progressive deepening of tone towards the foreground that helps to create a strong feeling of recession.

STICK TO THE MORE SUBDUED SUNSETS
AND AVOID THOSE WITH TOO MANY
COLOURS

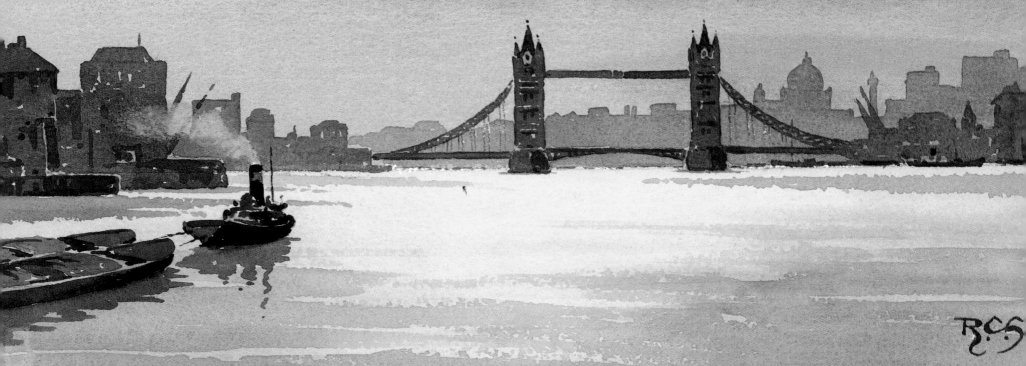

Au Coin de la Rue

PALETTE

CADMIUM YELLOW
RAW SIENNA
BURNT SIENNA
LIGHT RED
ALIZARIN CRIMSON
FRENCH ULTRAMARINE
WINSOR BLUE

PAPER

ARCHES 300LB (640GSM)
ROUGH

BRUSHES

TWO 1IN (2.5CM) FLATS
NO.10 AND NO.6 SABLES

This street-corner scene is the sort of subject one can find in the majority of French towns, and one that can be sketched in comfort from a roadside café. Here the road zigzags conveniently into the heart of the painting and leads the eye to the distant church spire. The time is early evening in high summer and the strong lateral shadows help to link both sides of the painting together. There is a satisfying harmony in the composition, with the larger tree and more distant buildings on the left balancing the smaller tree and nearer buildings on the right. There is plenty of detail as one would expect of a lively street scene, but most of it has been suggested rather than minutely portrayed, with the distant figures

Pen, brush and indian ink

The pale figures are placed against a dark background and the dark figures against a pale background

as little more than multi-coloured dots of paint.

The sky was a pale variegated wash of dilute light red and raw sienna, with an increasing proportion of french ultramarine towards the top right. The trees went in next because I was anxious to convey their ragged-edged shapes fluently and loosely. If the background is painted first and spaces left for the trees, those spaces can easily end up looking too solid and the trees painted within them unnatural and unconvincing.

Notice the variety of soft colours in the more distant buildings, with the proportion of french ultramarine increasing with the distance so as to indicate recession.

UNLESS THE BACKGROUND IS SO PALE THAT IT CAN BE OVER-PAINTED WITHOUT SHOWING THROUGH, IT IS OFTEN BETTER TO PAINT FOREGROUND FOLIAGE FIRST

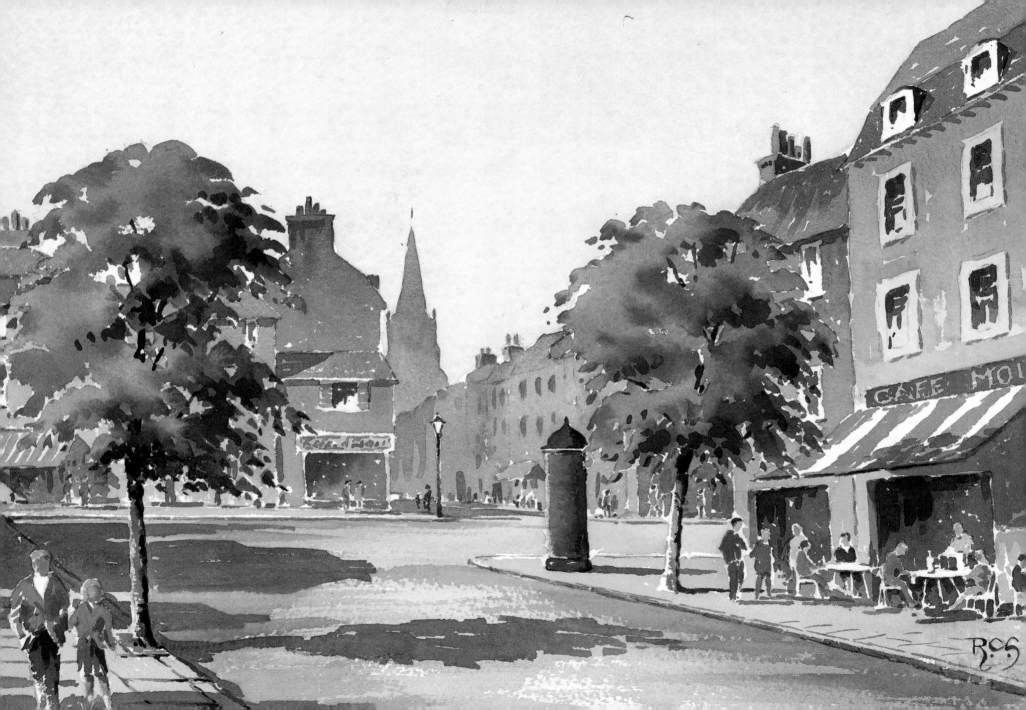

PALETTE

RAW SIENNA
LIGHT RED
FRENCH ULTRAMARINE

PAPER

ARCHES 300LB (640GSM)
ROUGH

BRUSHES

1IN (2.5CM) FLAT
NO.12 AND NO.8 SABLES

URBAN TWILIGHT

This is another painting in which I have tried to capture something of the murky atmosphere of a misty inner-city evening with shining street lights creating a contrasting note. The scene may not appeal to the watercolourist whose main interest is in rural scenes, but it does us all good to get right away from our favourite subjects from time to time and tackle something entirely different.

Here the roadway curves back into the painting, carrying the eye towards the railway arch which forms the focal point. The solitary cyclist might well have been pedalling into the painting instead of out of it, but on this side of the road he is making a more successful contribution to the composition.

The treatment of the scene is very simple, with the sky a variegated wash of french ultramarine and light red, which merges into palest raw sienna round the street lights. The buildings are mainly flat washes of the same colours in varying proportions and deeper tones. The more distant features — the church spire and factory chimneys — are painted in lighter, greyer tones to make them recede. Detail has been confined to the foreground — the flagstones of the pavements and the bricks of the low wall on the left. The nearer buildings on either side frame the scene and help to concentrate attention on what lies beyond. Once again I have used just three colours and this helps to give the painting a feeling of unity.

Water-soluble pencil

The halos around the street lights suggest most effectively the presence of mist

REFLECTIONS ON THE SURFACE OF THE
ROAD AND PAVEMENTS ADD INTEREST AND
LIFE TO THE COMPOSITION

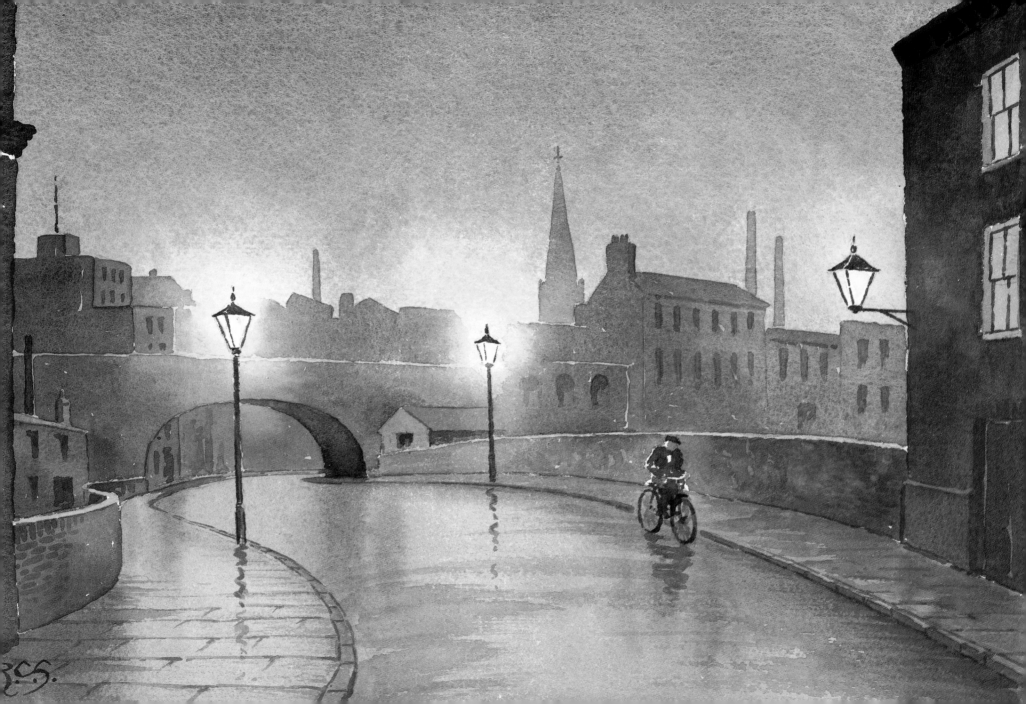

PALETTE

RAW SIENNA
BURNT SIENNA
LIGHT RED
FRENCH ULTRAMARINE
WINSOR BLUE

PAPER

ARCHES 300LB (640GSM)
ROUGH

BRUSHES

TWO 1IN (2.5CM) FLATS
NO.12 AND NO.8 SABLES

REFLECTIONS IN VENICE

The composition of this Venetian canal scene needed careful thought and planning. The branching waters of the canal could easily have carried the eye off the paper both to the left and to the right, but they were prevented from doing so by the placement of the foreground buildings. The church tower constitutes a focal point and is placed off centre to the left – not far from the golden mean – and some of the main construction lines lead the eye towards it. The right-hand boat and the leaning mooring pole on the left also point towards it.

The theme of the painting is the interplay of light and shade, and the position of the sun was just right. A couple of hours earlier it would have

Notice the warm, reflected light in the lower part of the diagonal cast shadow

Brush, pen and sepia ink

been behind the central buildings which would then have been almost entirely in shadow. So however inconvenient it may be, it is always worth being patient and waiting until the direction of the light is ideal for your purposes – it can make all the difference to the success of a painting.

The heat of the sun had drained much of the colour from the sky, which I kept very simple to avoid any competition with the fairly complex scene below. I decided to keep the reflections soft-

edged for much the same reason, and only those of the foreground gondolas and mooring poles are hard-edged, to make them come forwards.

WHEN THE ADJACENT COLOURS ARE REDS
AND WARM BROWNS, THE PLACING OF A
COMPLEMENTARY GREEN CLOSE BY STRIKES
A VIBRANT NOTE

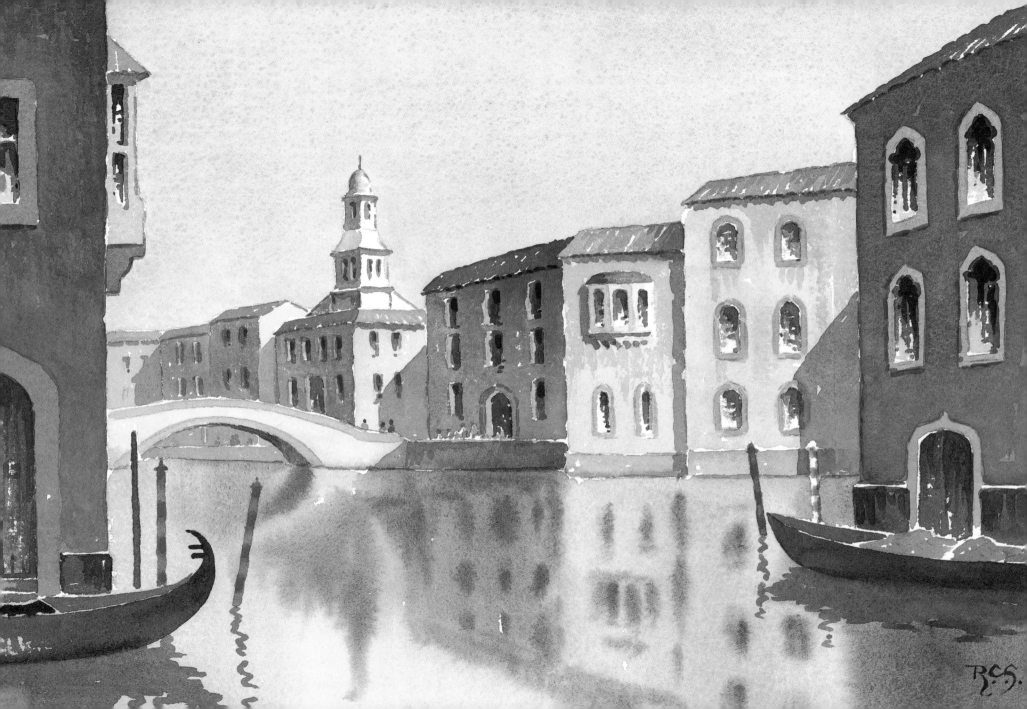

PALETTE

RAW SIENNA
CADMIUM YELLOW
BURNT SIENNA
LIGHT RED
FRENCH ULTRAMARINE
PAYNE'S GREY

PAPER

ARCHES 300LB (640GSM)
ROUGH

BRUSHES

NO.12 AND NO.8 SABLES

LEATHER LANE MARKET

Street markets are full of life and interest for artists prepared to have a shot at tackling the human figure. The London market illustrated here is usually far more crowded than I have shown it, but to do full justice to the colourful produce stalls and to control the composition, I decided to simplify drastically. Here the time is dusk, with the street lamps coming on and lights appearing in shop fronts and windows. These add to the attraction of the scene and not only illuminate the brightly coloured banks of fruit and vegetables, but also provide soft halos in the misty air and pools of light in the wet street below. Dry tarmac is an uninteresting colour, but after a

Conté crayon

shower of rain it reflects the lights and colours above and becomes altogether more appealing.

The figures are painted quite simply and I have concentrated on posture rather than detail. To provide tonal contrast and make them stand out, I have placed them mainly against lighted windows and other areas of pale tone. Apart from the greens, oranges and reds of the greengroceries and the warm yellows of the sky, the lamps and lit windows, the dominant colour is a warm grey — a mixture of french ultramarine and light red in

varying proportions — and it is this that helps to convey an impression of twilight.

Painting in a busy, jostling street market is not really a practical proposition, but quick sketches can be made for use later in the studio.

The dark figure provides tonal contrast with its paler surroundings

> WHEN TACKLING THE HUMAN FIGURE, CONCENTRATE ON THE FIGURE'S POSTURE RATHER THAN DETAIL

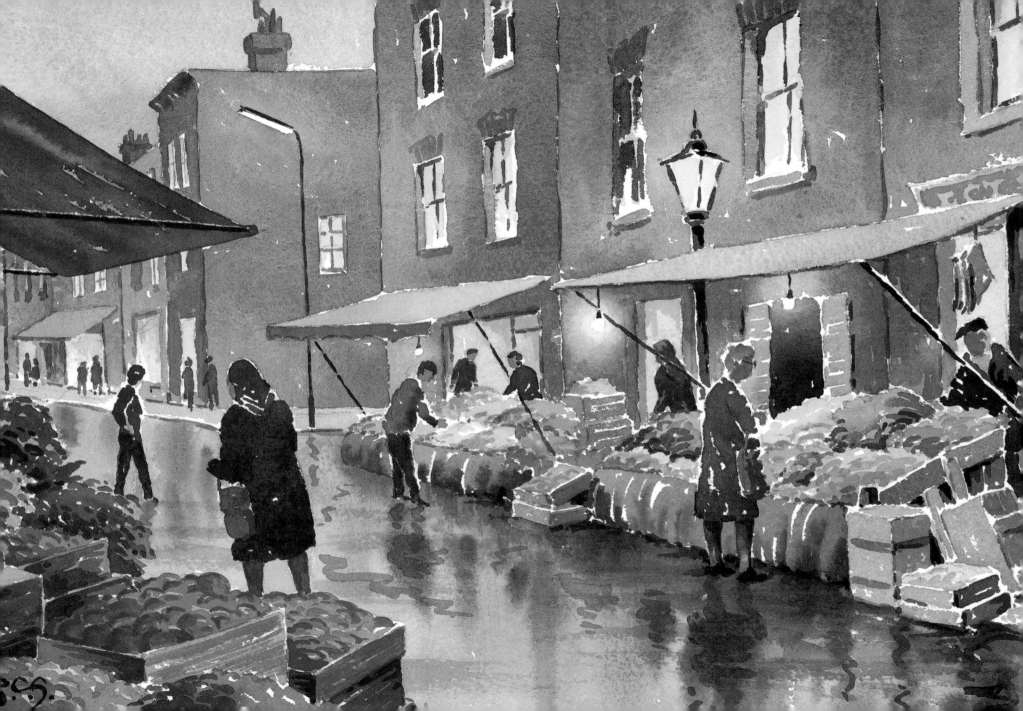

MISTY MORNING ON THE WAAL

PALETTE

RAW SIENNA
BURNT SIENNA
LIGHT RED
FRENCH ULTRAMARINE

PAPER

ARCHES 300LB (640GSM)
ROUGH

BRUSHES

TWO 1IN (2.5CM) FLATS
NO.10 AND NO.6 SABLES

The lower reaches of the River Waal in the Netherlands are often shrouded in mist and provide wonderful subjects for the watercolourist with an eye for atmosphere. The medium of watercolour is particularly well suited to capture these subtle effects and this is where the wet-in-wet technique comes into its own.

A low sun trying to pierce the fog provided the background for this painting and I decided to apply a variegated wash to the whole paper – palest raw sienna in the centre merging into light red with a little added french ultramarine around the edges. These washes had to be prepared in advance and then applied quickly with large brushes. The distant buildings on the left and their reflections were painted wet-in-wet while the background wash was still moist, with decreasing emphasis towards the right as they receded. Slightly darker accents were added before the paper was quite dry to give some indication of form.

The tug with its plume of smoke, the barges, the cranes and the riverside buildings on the right were painted in much stronger tones once the paper was quite dry and their crisper treatment contrasts with the paler, soft-edged handling of the distant buildings on the left to provide a convincing feeling of recession.

I used only three colours – raw sienna, light red and french ultramarine – and this narrow range contributed to the unity of the painting and helped it to 'hang together'.

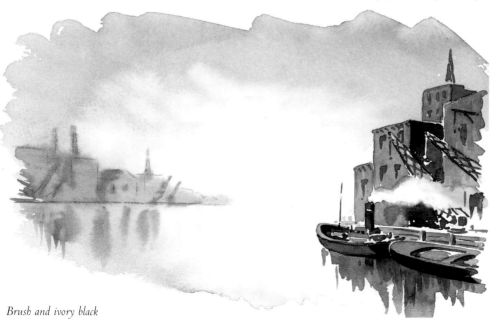

Brush and ivory black

The wet-in-wet treatment nicely captures the misty appearance of the distant riverside buildings

THE WET-IN-WET TECHNIQUE IS
INVALUABLE IN CREATING MISTY EFFECTS
AND SHOULD BE A PART OF EVERY
WATERCOLOURIST'S REPERTOIRE

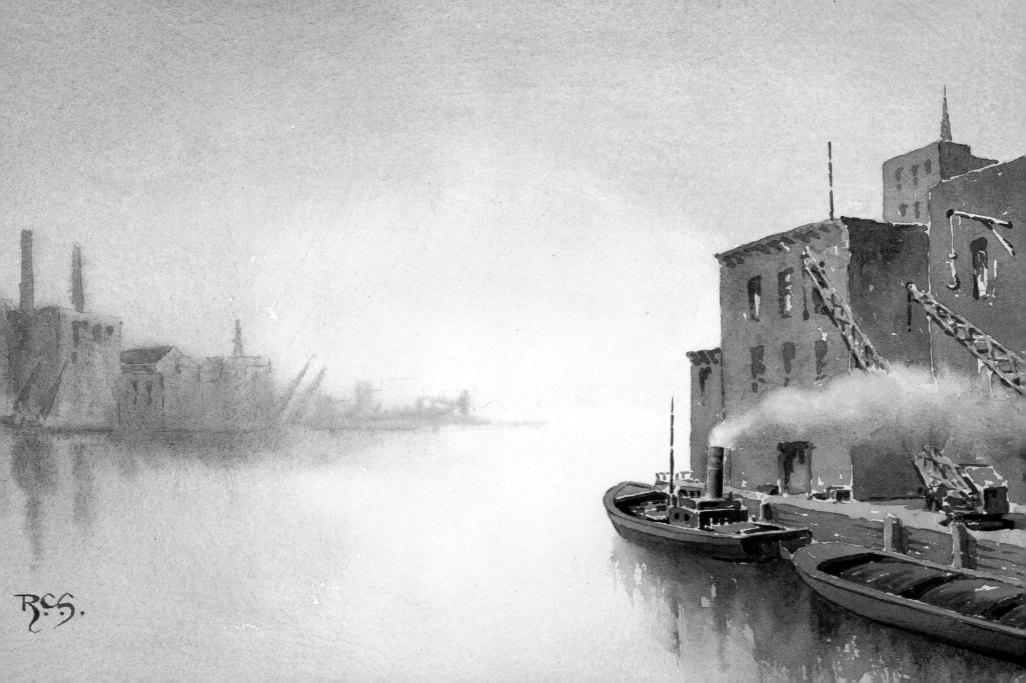

CROSSROADS, SOUTH-EAST LONDON

The 'Victorian' areas of Greater London sprang up in the nineteenth century in response to the capital's rapidly increasing population. With the enormous outward expansion of suburbia in more recent times, they are now regarded as inner-city areas. Sadly, much original architecture was destroyed during World War II and, more recently, by property developers, and it has been replaced by unsightly and out-of-scale tower blocks. However, there are still some districts that have managed to retain much of their

Pen and indian ink

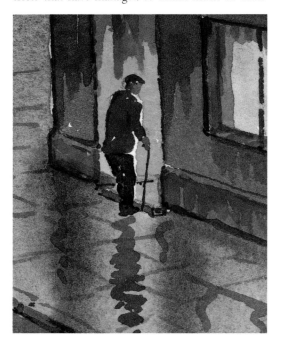

The old man entering his local pub adds a little human interest. Victorian paintings frequently contained such touches

original character. These provide fascinating subject matter for the perceptive painter, and many are coming to realise that there is a wealth of interesting material on their doorsteps.

There is usually far more traffic and also many more pedestrians in this busy intersection, but I drastically reduced the numbers of both as I was more interested in the buildings. Once again, I have painted the scene after a recent shower of rain and so have lively reflections to conjure with instead of the drab colour of dry tarmac. The evening light contributed to the atmosphere and enabled me to include lighted windows to add interest to the buildings.

The sky was a wash of dilute raw sienna with just a hint of light red and french ultramarine at the horizon, and the pale silhouette of distant buildings was a slightly stronger mixture of the last two colours. The lighted windows were raw sienna with a little light red here and there, and the buildings and their reflections were varying combinations of all three colours.

A WARM EVENING LIGHT CAN ENLIVEN A DRAB SUBJECT AND INFLUENCE EVERY PART OF IT

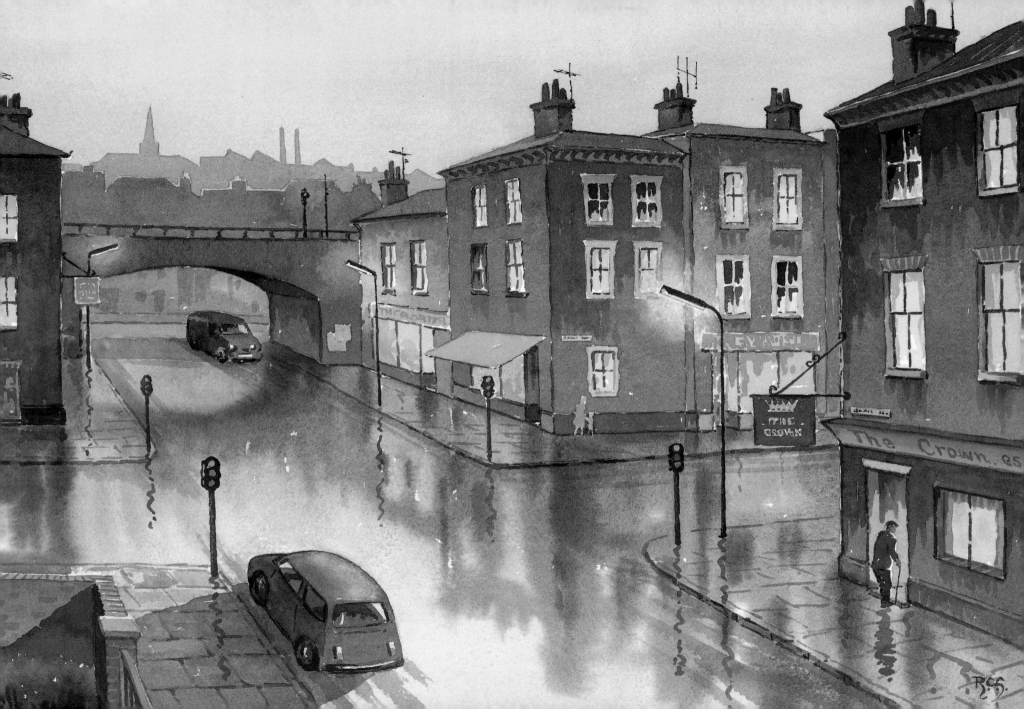

RURAL SCENES

*I*t is a common misconception that every attractive rustic view will automatically make a satisfactory painting, and that all one has to do is find such a scene and begin painting. This approach is responsible for many a disappointment, for there are other vital considerations to take into account. One of these is overall design. A successful painting will present a pleasing design or pattern quite independent of the significance of the subject matter. Related to this is a good composition. Is there balance and harmony in the arrangement of the elements of the subject? Is there a well defined centre of interest? Do some of the construction lines lead the eye to this focal point?

With experience, all these matters become second nature and so influence one's choice of subject, but in the earlier stages they need to be consciously borne in mind.

Once you have identified a subject that appeals to you, spend a little time examining it until you find the most effective angle, perhaps with the aid of several thumbnail sketches – an original viewpoint generally has more impact than a safe, conventional one. Do not then be content just to produce an accurate representation. Ask yourself if there is some aspect or feature that strikes a chord in your imagination and try to convey something of this in your treatment of the subject.

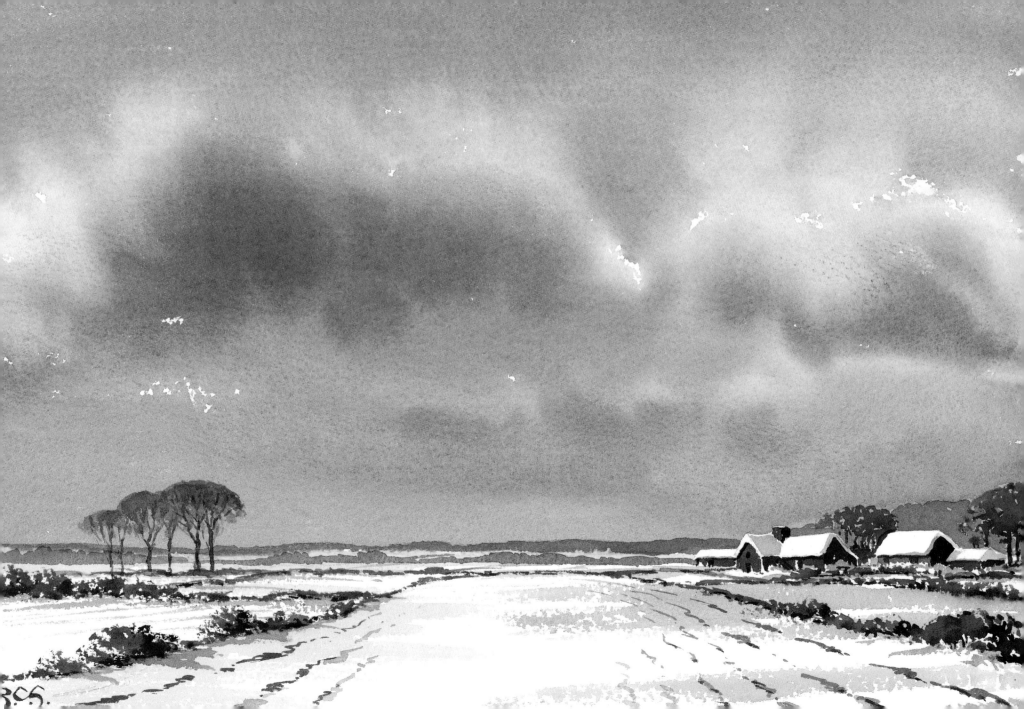

WINTER IN THE WEALD OF KENT

PALETTE

RAW SIENNA
BURNT SIENNA
LIGHT RED
FRENCH ULTRAMARINE

PAPER

SAUNDERS WATERFORD
300LB (640GSM) ROUGH

BRUSHES

1IN (2.5CM) FLAT
NO.12 AND NO.6 SABLES

It was the English watercolourist, Rowland Hilder who, earlier this century, reawakened the interest of painters and public alike to the attraction of the countryside in winter, and his highly individual style and approach captured its appeal and its magic.

This farm scene appealed to me for a number of reasons. I liked the way the warm colours of the sky, the buildings and the nearer foliage contrasted with the cooler grey of the snow shadows and the distant hills. I also liked the way the farm track curved into the painting and led the eye to

the group of farm buildings with their characteristic oasthouses and their stand of surrounding trees. This group is balanced by the large tree on the right, and the two are connected by the line of hills and the hedge, and by the lateral shadows in the snow.

The sky was a pale wash of raw and burnt sienna to which I added the grey clouds, wet-in-wet, with a mixture of french ultramarine and light red. The light red bled a little from this wash to provide a warm edge to the clouds. The trees, the buildings and the lines of ploughed soil which

The snow-covered barn roof contrasts with the deeper tones of the background trees

showed through the snow were all painted in deep tones to make the snow — just the white of the paper — shine by contrast. The man and his dog were an afterthought, and were included to provide a touch of human interest.

Charcoal pencil

*I*F YOU USE PALE TONES FOR THE LOWER
SKY, YOU CAN SAFELY PAINT NEARER
OBJECTS OVER IT

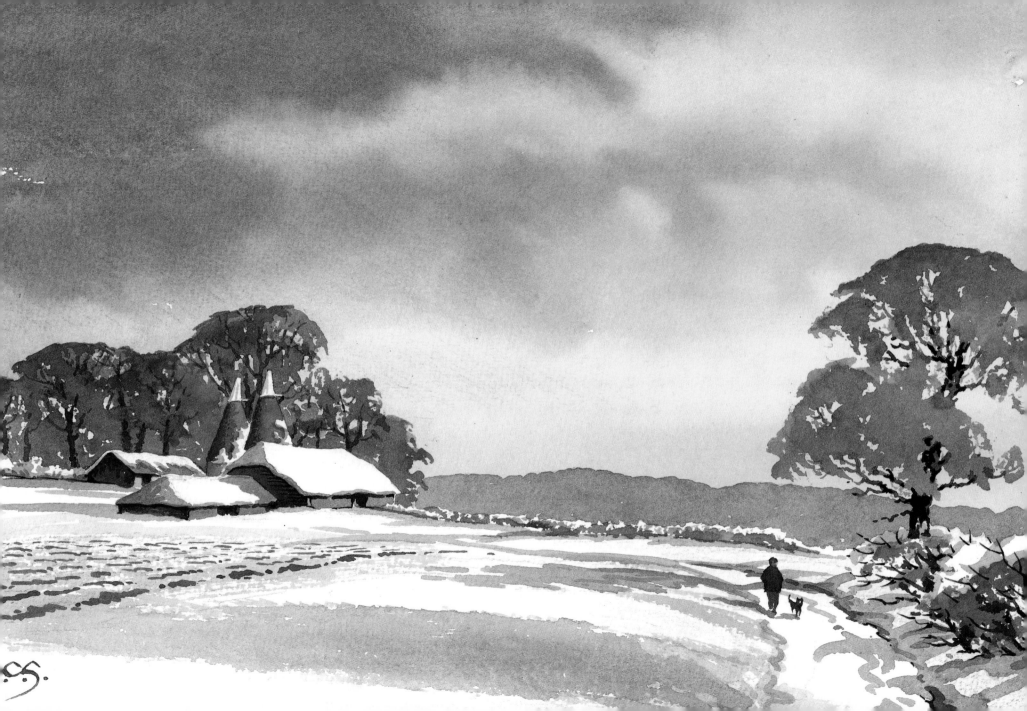

PALETTE

RAW SIENNA
BURNT SIENNA
LIGHT RED
FRENCH ULTRAMARINE
WINSOR BLUE

PAPER

SAUNDERS WATERFORD
300LB (640GSM) NOT

BRUSHES

1IN (2.5CM) FLAT
NO.6 AND NO.10 SABLES

These flowers are mainly the white of the paper, and their form is created by the deep green of the surrounding wash

THE OLD FARMHOUSE

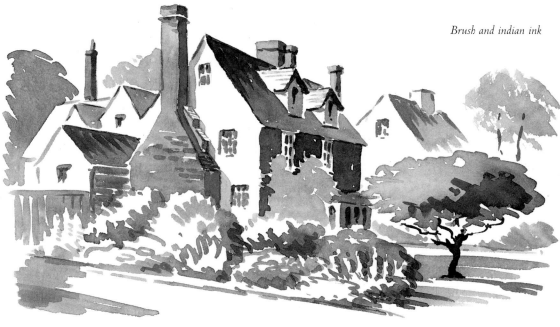

Brush and indian ink

Parts of this old building date from the fifteenth century, and later bits have been added in a delightfully haphazard manner over the years. After some reconnaissance I decided that this was the most promising angle, for it allowed me not only a glimpse of the various additions at the rear but also enabled me to include one sunlit and one shadowed elevation – an arrangement which always helps to create a three-dimensional effect. It also allowed me to make a feature of the massive old chimney stack situated on the gable end of the house.

With plenty going on below, I decided the comparatively small area of sky needed somewhat restrained treatment so that it would not compete for attention. The distant trees also needed to

be played down for the same reason and for them I used a flat wash of pale blue-grey (french ultramarine and light red).

One of the questions which always arises when one is tackling a building as close as this is how much detail to include in painting the component materials. Some indication is undoubtedly necessary but one should avoid the temptation to paint every brick and tile, a chore which almost always produces a laboured and over-worked effect. A few random marks will usually suffice and the viewer's imagination will supply the rest.

Always look for the less obvious colours in your subject and do them full justice – they add greatly to the interest of any passage. Notice the variety of colours in the shadowed side of the farmhouse and in the fence on the left.

ALWAYS BE ON THE LOOKOUT FOR SUBTLE COLOURS WHICH THE LESS OBSERVANT MIGHT NOT NOTICE — THEY WILL ADD INTEREST TO YOUR WORK

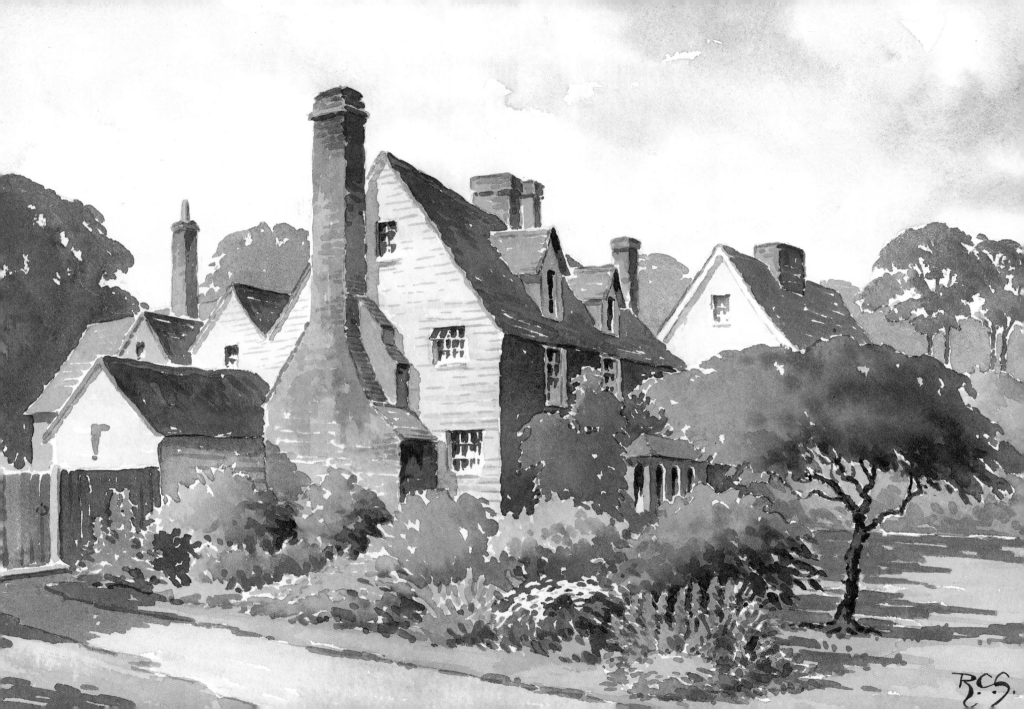

WINDMILL FARM

PALETTE

RAW SIENNA
BURNT SIENNA
LIGHT RED
FRENCH ULTRAMARINE
PAYNE'S GREY

PAPER

ARCHES 300LB (640GSM)
ROUGH

BRUSHES

THREE 1IN (2.5CM) FLATS
NO.12 AND NO.8 SABLES

This farmstead presented several attractive compositional possibilities, but I eventually settled for this one because I liked the way the buildings and the surrounding trees overlapped and so related to one another. The sunlit buildings registered effectively against the darker foliage, and the windblown washing struck a lively, contrasting note in the centre. A gate will always carry the eye to what lies beyond, and this one leads into the centre of the painting. The large tree on the left provides useful compositional balance, and it is linked to the main group by the long, low outbuilding and the lines of hedge.

The billowing cumulus clouds were more interesting than the foreground grassy field and so I gave them plenty of space by adopting a low horizon. The line of distant hills was a flat wash of french ultramarine and light red to which I added further touches of the same mixture to indicate woods and hedges. The sunlit tiled roofs and the brick walls of the buildings were of burnt sienna and light red, with a touch of green in the lower courses. A much stronger mix of light red and french ultramarine served to portray the shadowed elevations.

I used Payne's grey with raw sienna for the trees and hedges, with burnt sienna added here and there for the early autumnal tints. The rough grass in the foreground was a broken wash of raw sienna and a touch of Payne's grey, with a little added texturing of the same mixture.

The line of washing here provides both counterchange and movement

Conté pencil

*A*VOID BECOMING TOO INVOLVED WITH
FOREGROUND DETAIL. A BROKEN WASH CAN
OFTEN SUGGEST TEXTURE EFFECTIVELY
AND ECONOMICALLY

PALETTE

RAW SIENNA
BURNT SIENNA
LIGHT RED
FRENCH ULTRAMARINE
WINSOR BLUE

PAPER

SAUNDERS WATERFORD
300LB (640GSM) NOT

BRUSHES

THREE 1IN (2.5CM) FLATS
NO.12 AND NO.8 SABLES

Brush and ivory black

IN THE WEALD

I painted this quick impression of a Kentish farmstead as a demonstration to a group of students whose work was suffering from overworking and a surfeit of detail. It was intended to show that a fresh and lively painting could result from a bolder and speedier approach and it was timed at 17 minutes, no doubt helped by the quick-drying conditions of a sunny, breezy day.

Although it underlines the point I was making, it rather obscures an equally important one — that while the actual painting process should be speeded up, you should allow plenty of time for reconnaissance and periodic assessment of your work as it proceeds. In other words, plan each

stage with care and forethought, but then apply your washes quickly and directly.

I again adopted a low horizon because I felt the sky with its billowing cumulus clouds was more interesting than the foreground. The sunlit clouds were palest raw sienna, the grey shadows a dilute mixture of french ultramarine and light red, and the blue sky french ultramarine. These three washes were applied in quick succession and allowed to blend softly together, though some hard edges were preserved. The distant wooded hills were a flat wash of the same grey. The buildings went in next, mainly in burnt sienna and light red, with added french ultramarine for the shadows. The

background trees were added in deeper tones, for the sake of contrast, in a single variegated wash to which the shadows were added, wet-in-wet.

The sunlit gable stands out boldly against the darker tones of the autumnal trees

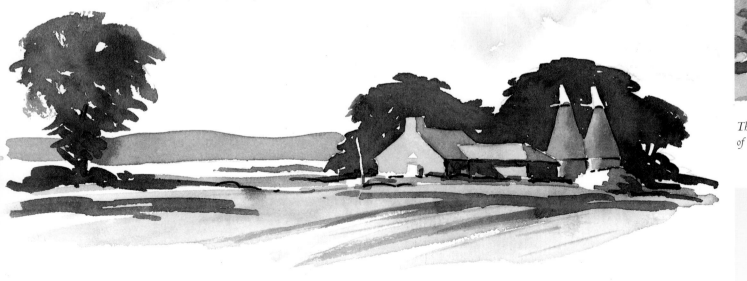

PRACTISE APPLYING WASHES QUICKLY AND
BOLDLY BUT ALLOW AMPLE TIME FOR
PLANNING AND ASSESSMENT

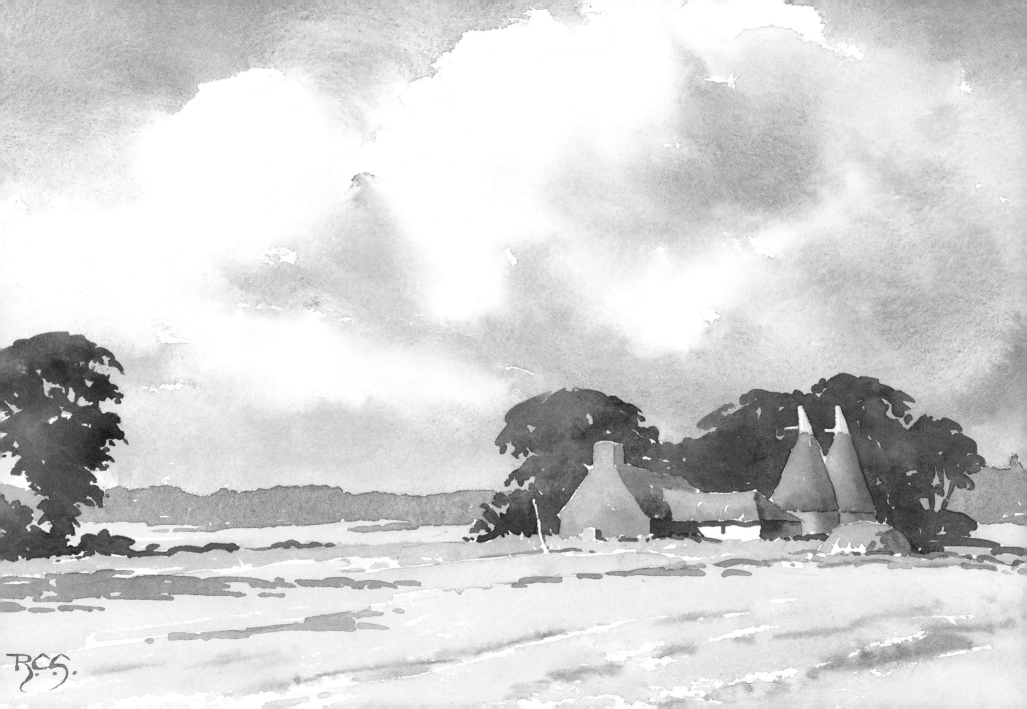

PALETTE

RAW SIENNA
BURNT SIENNA
LIGHT RED
FRENCH ULTRAMARINE
PAYNE'S GREY

PAPER

ARCHES 300LB (640GSM)
ROUGH

BRUSHES

TWO 1IN (2.5CM) FLATS
NO.10 AND NO.8 SABLES

Charcoal pencil

COTSWOLD FARMHOUSE

Although a single building rarely has the compositional appeal of a clustered group, this one has a pleasantly complex shape which makes it an attractive subject and a useful centre of interest. The farm track leads the eye obligingly towards the building and the farm pond almost seems to point to it. I introduced a large tree on the right and this, together with its reflection, helps to balance the composition.

There was a luminous quality about the sky and I have tried to indicate this by using very pale washes and gentle shadows. The direction of the light produces sunlit and shadowed elevations which help to give the farmhouse a feeling of solidity. The farmhouse walls were a pale wash of raw sienna to which I added a broken wash of raw and burnt sienna plus a little french ultramarine to suggest the honey-coloured Cotswold stone, but leaving the base wash to stand for the mullions and other areas of dressed stone. I indicated the stone slates of the roof by leaving horizontal chinks of white and adding just a few darker accents for the lower courses. Notice the hint of reflected light in the shadowed gable.

The time of year was late September and some of the trees were beginning to show the russet hues of autumn. Once again I have used deep colours for the background trees (raw and burnt sienna and Payne's grey in varying proportions) and these contrast effectively with the paler stone of the farmhouse.

The diagonal shadow adds interest and authenticity

WORK OUT IN ADVANCE HOW YOU ARE
GOING TO DEPICT TEXTURED SURFACES,
SUCH AS STONE MASONRY. IT IS NOT
ADVISABLE TO EXPERIMENT ON YOUR
WATERCOLOUR PAPER

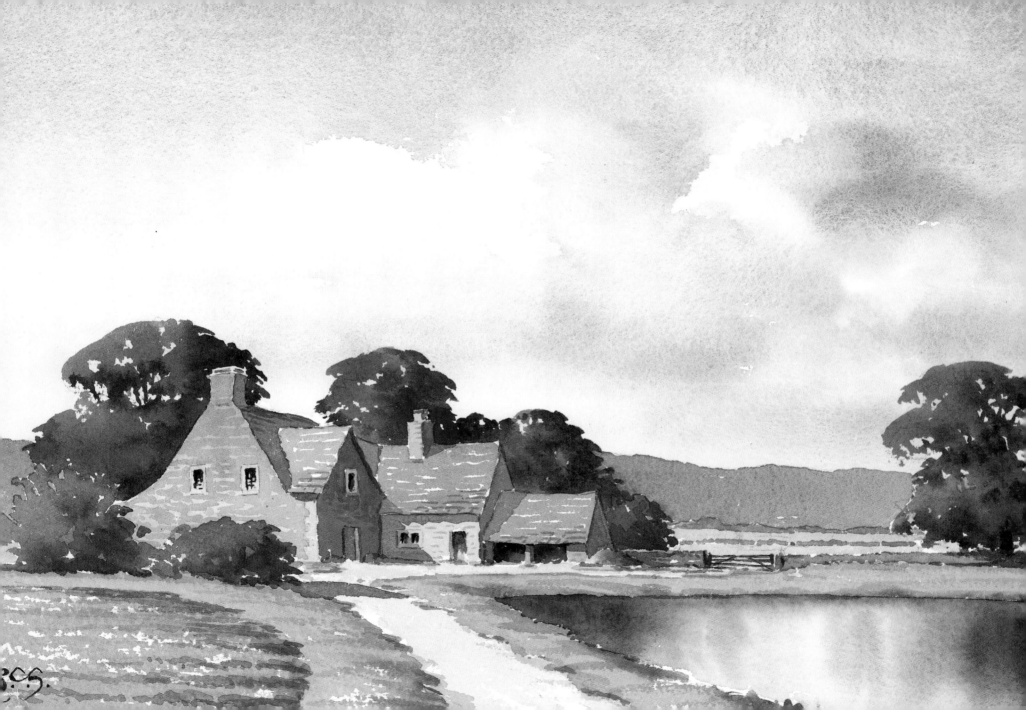

PALETTE

RAW SIENNA
BURNT SIENNA
LIGHT RED
FRENCH ULTRAMARINE
PAYNE'S GREY

PAPER

ARCHES 300LB (640GSM)
ROUGH

BRUSHES

TWO 1IN (2.5CM) FLATS
NO.12 AND NO.8 SABLES

HOME FARM, EVENING

This was the first of several sketches of this remote Kentish farm and probably the most successful. I like the way the farm track leads the eye towards the group of old buildings, reflected softly in the stretch of clear foreground water. The trees on either side help to balance the composition, and the line of hills links all the elements together. The time was early evening and there was a late summer stillness in the air that I wanted to capture. The soft afterglow was coming from the right as the treatment of the sky suggests — an overall wash of pale raw sienna to which the soft-edged clouds were added, wet-in-wet, with a weak wash of french ultramarine and light red. The distant hills and trees were a stronger mixture of the same soft grey, and this not only suggests the misty tints of evening but, by contrasting with the stronger, warmer colours of the foreground, provides a convincing feeling of recession.

The nearer trees were strong washes of Payne's grey with raw and burnt sienna in varying proportions, but their shadows were french ultramarine and light red, and this helps to give them a slightly misty appearance. The russet colours of the foreground hedge — mainly burnt sienna — provide further contrast and reinforce the painting's aerial perspective.

Although the treatment suggests peace and

The grey silhouettes of the oasthouses suggest the mistiness of early evening

tranquillity, there is still plenty of tonal contrast to add punch and interest, as in the deep-toned trees against the luminous sky and the foreground grass verge against the patch of pale water.

Brush and ivory black

CAPTURING ATMOSPHERE IS FAR MORE
IMPORTANT THAN RECORDING DETAIL

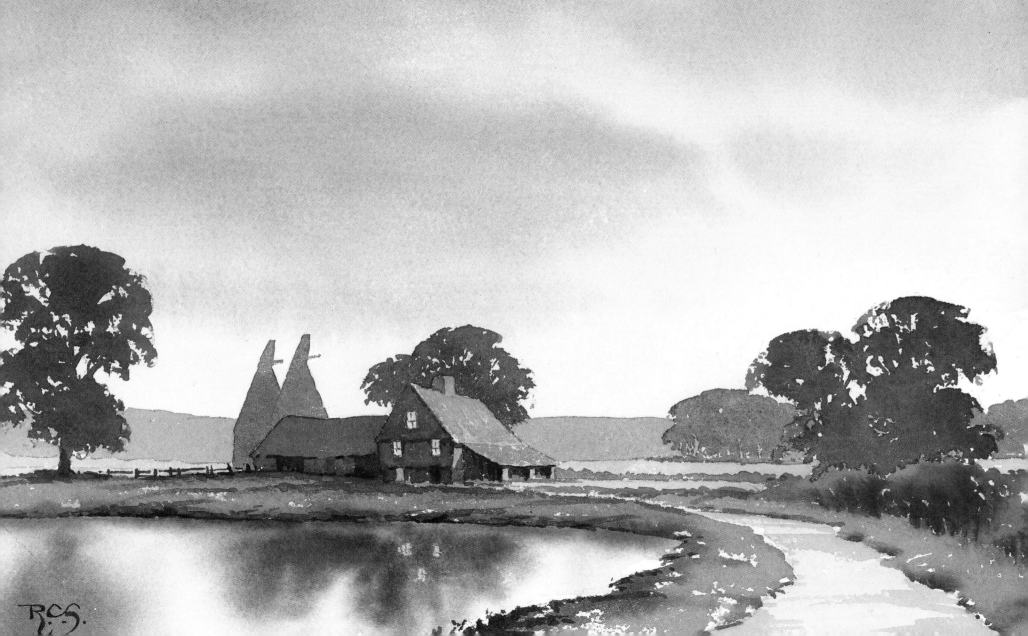

PALETTE

RAW SIENNA
BURNT SIENNA
LIGHT RED
FRENCH ULTRAMARINE
PAYNE'S GREY

PAPER

ARCHES 300LB (640GSM)
ROUGH

BRUSHES

TWO 1IN (2.5CM) FLATS
NO.10 AND NO.8 SABLES
RIGGER

Green added to the deep tones of the willow trunk suggest its mossy base

THE MEDWAY IN WINTER

Brush and indian ink

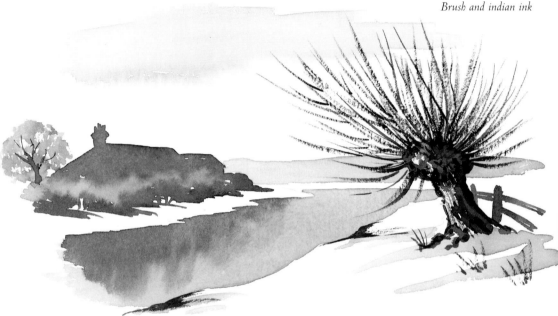

This farm, with its typical Kent oasthouses, lies close to a bend in the River Medway, with views right across the level fields to the North Downs. The group of buildings is nicely balanced by the bold form of the pollarded willow and although the two are separated by the river, which curves satisfactorily into the centre of the painting, the line of distant hills serves well as a connecting link.

When painting winter scenes you should always remember that the snow is sure to be the lightest part of the subject, and that includes the sky, particularly if, as here, it is dull and overcast. The snow is just the white of the paper, but the Arches brand has a hint of cream in it, and this accords better than dead white with the light conditions depicted.

I established the cloudy sky with an overall wash of pale raw sienna to which I applied, wet-in-wet, broad washes of grey (french ultramarine and light red). When this was dry I put in the distant downs with a flat wash of the same grey, and also the buildings with a slightly stronger version, with additional light red for the farmhouse walls. I then added the line of rough hedge while the buildings were still damp so that some merging took place, though the lower margin of the hedge was crisp against the snow.

The willow was strongly painted in deep tones to provide compositional balance, with some dry brush work to vary the treatment of the withies.

THE WHITE OF THE PAPER USUALLY SERVES
WELL FOR SNOW. SNOW SHADOWS TAKE
THEIR COLOUR FROM THE SKY

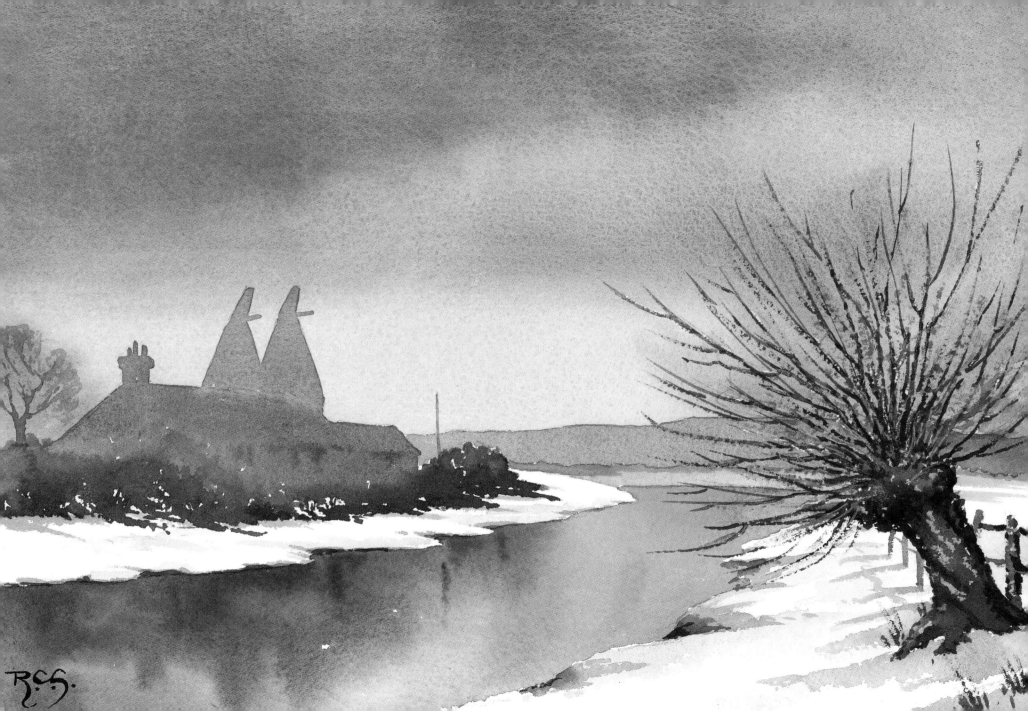

PALETTE

RAW SIENNA
BURNT SIENNA
LIGHT RED
FRENCH ULTRAMARINE
WINSOR BLUE

PAPER

ARCHES 300LB (640GSM)
ROUGH

BRUSHES

1IN (2.5CM)
NO.12, NO.8 AND NO.6
SABLES

Pen, brush and indian ink

KENTISH FARM, EVENING

This cluster of farm buildings, with its variety of overlapping shapes and contrasting tones, makes an interesting natural composition. It is the sort of subject for which it is well worth waiting for the sun to be in the best position to ensure a pleasing mixture of sunlit and shadowed elevations. It is worth repeating that these not only make the buildings more interesting but give them a solid, three-dimensional appearance. I made the most of the opportunities for counterchange to give the painting life and sparkle: for instance, the brightly lit oast cowls against the dark trees, and

the five-barred gate and fence posts against the shadowed side of the barn. I used masking fluid to preserve the crispness and brightness of the edges. Notice how the light catching the top of the barn roof serves the useful purpose of separating the deep tones of the roof from the dark trees behind. The farm gate to the right leads the eye to the pale fields and the glimpse of the blue-grey downs beyond.

I used raw sienna and light red for the warm colour of the evening sky, for the sunlit elevations of the brick and tile of the farm buildings, and

for the glow reflected in the pond. The roof of the foreground shed on the left was corrugated iron, with some dark paint still in place but some areas of red rust, and this provided a further opportunity for using rich, warm colour.

The white cowls of the oasthouses register effectively against the dark trees behind

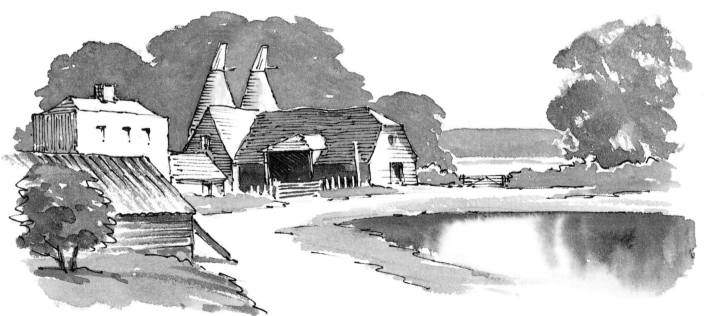

MAKE SURE THE WARM COLOURS OF AN
EVENING SKY INFLUENCE EVERY PART OF
YOUR PAINTING

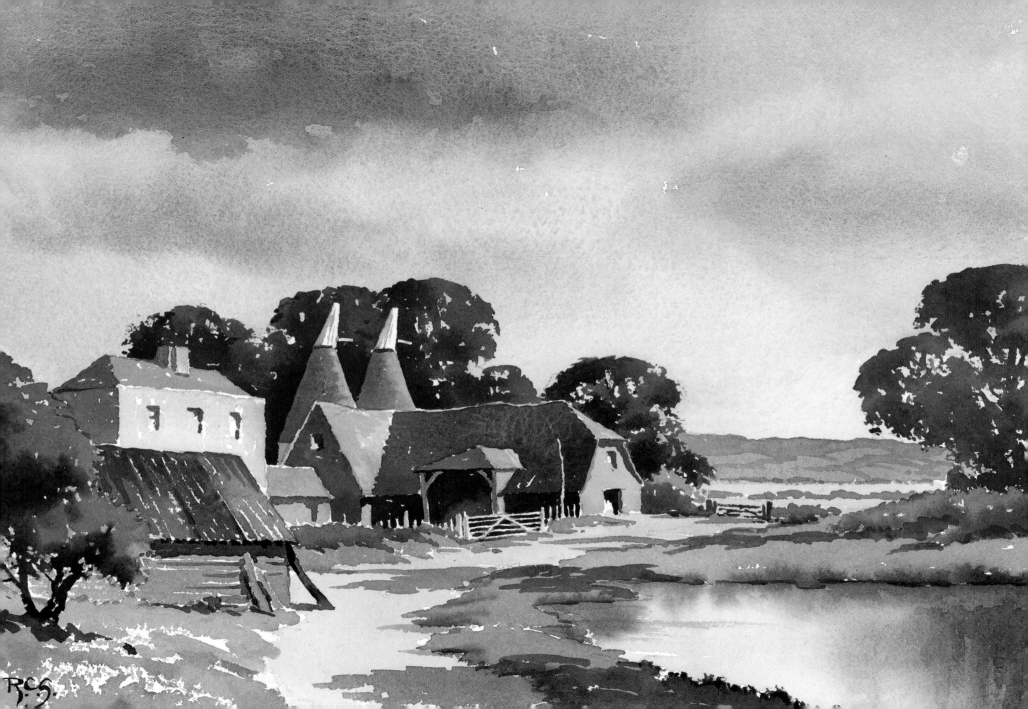

MOUNTAIN SCENERY

*W*atercolour is the perfect medium for capturing the subtle and some-times dramatic colours and tones of mountain terrain, and the wet-in-wet technique is ideal for rendering misty outlines and soft-edged cloud effects. An added advantage is that all the equipment one needs will be light and easy to carry, an important consideration where much stiff climbing is involved. Painting mountain scenery need not be the sole preserve of the young and fit, however, and with careful reconnaissance, splendid compositions may be viewed from lower levels.

Remember that the weather in mountainous areas is notoriously fickle and it is always a sensible precaution to set forth with adequate protection against the elements, both for oneself and one's drawing board.

Capturing atmosphere is of vital importance in this field, and washes of sufficient strength should be applied boldly and freely if the result is to carry conviction. Always bear in mind the need for a centre of interest, for mountain panoramas, however impressive, can make poor compositions without one. A dominant peak may well provide a strong centre of interest, but care should be taken over its positioning on the paper — neither too central nor too near the edge. If there is no obvious focal point, a strategically placed group of climbers, taken perhaps from a well stocked sketch book, may adequately fill the bill.

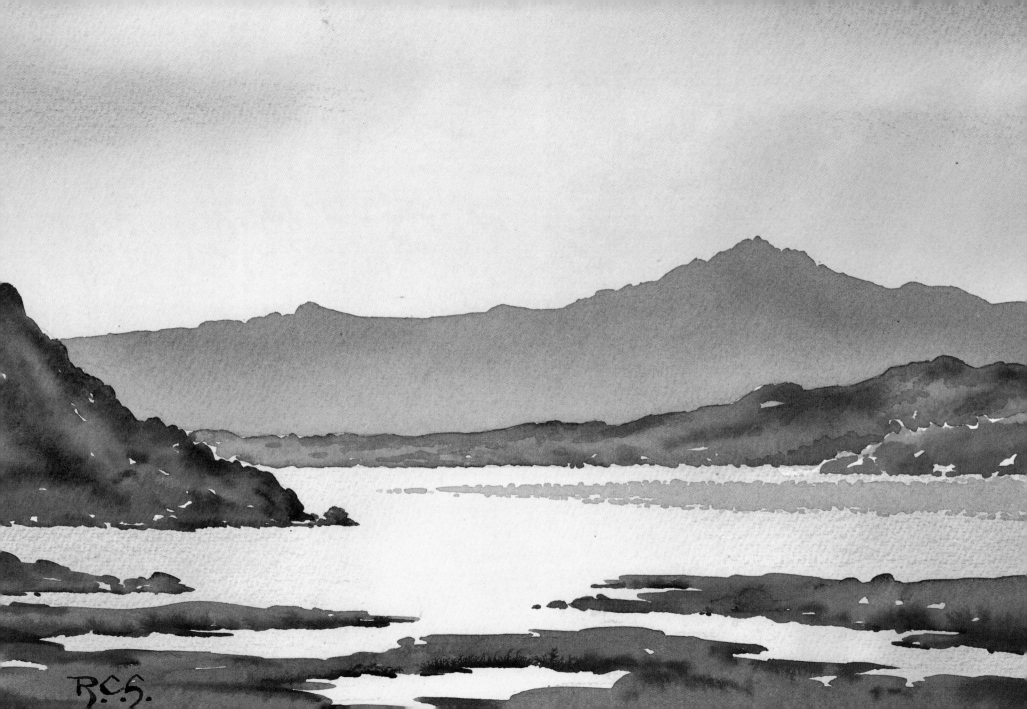

DUNVEGAN CASTLE, SKYE

PALETTE

RAW SIENNA
BURNT SIENNA
LIGHT RED
FRENCH ULTRAMARINE
WINSOR BLUE
PAYNE'S GREY

PAPER

ARCHES 300LB (640GSM)
ROUGH

BRUSHES

THREE 1IN (2.5CM) FLATS
NO.12, NO.10 AND NO.8
SABLES

I find brush and monochrome watercolour the ideal sketching medium for capturing the mood and atmosphere of mountain scenery. It is particularly suitable for subjects such as this where weather plays an important part for it enables one to depict lively cloud formations and broad areas of light and shade quickly and economically.

The composition is conventional but effective. The position of the castle, the dark mountain behind, its reflection and the shingly foreshore meant that most of the tonal weight was on the left of the painting, but the dark cloud formation and the wooded promontory on the right helped to restore the balance. The success of a painting largely depends upon the effective treatment of tonal contrasts and you should always be trying to place lights against darks. Here the light band of sky contrasts with the deeper tones of the clouds and the mountains. The castle itself registers boldly against its background, and the paler stretches of the loch contrast with the adjacent dark land forms.

I applied a dilute wash of raw sienna to the sky area and added the cloud shadows, wet-in-wet, with a strong mixture of french ultramarine and light red, adding Payne's grey here and there for added contrast. There were subtle colours in the sunlit expanses of the mountains and for these I used various combinations of raw sienna, Winsor blue, french ultramarine and light red.

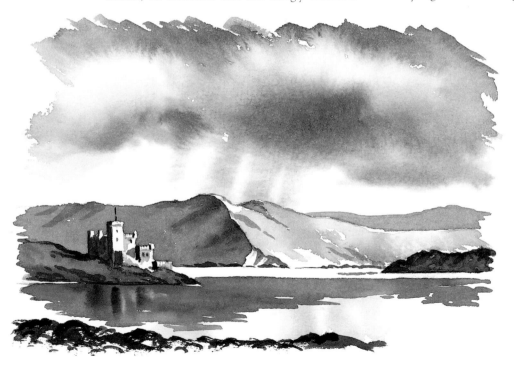

The sunlit and shadowed elevations of the castle both contrast tonally with their background

Brush and ivory black

*U*SE A BRUSH AND MONOCHROME WATERCOLOUR SKETCH AS A REHEARSAL IN MINIATURE FOR THE WATERCOLOUR TREATMENT OF THE PAINTING TO FOLLOW

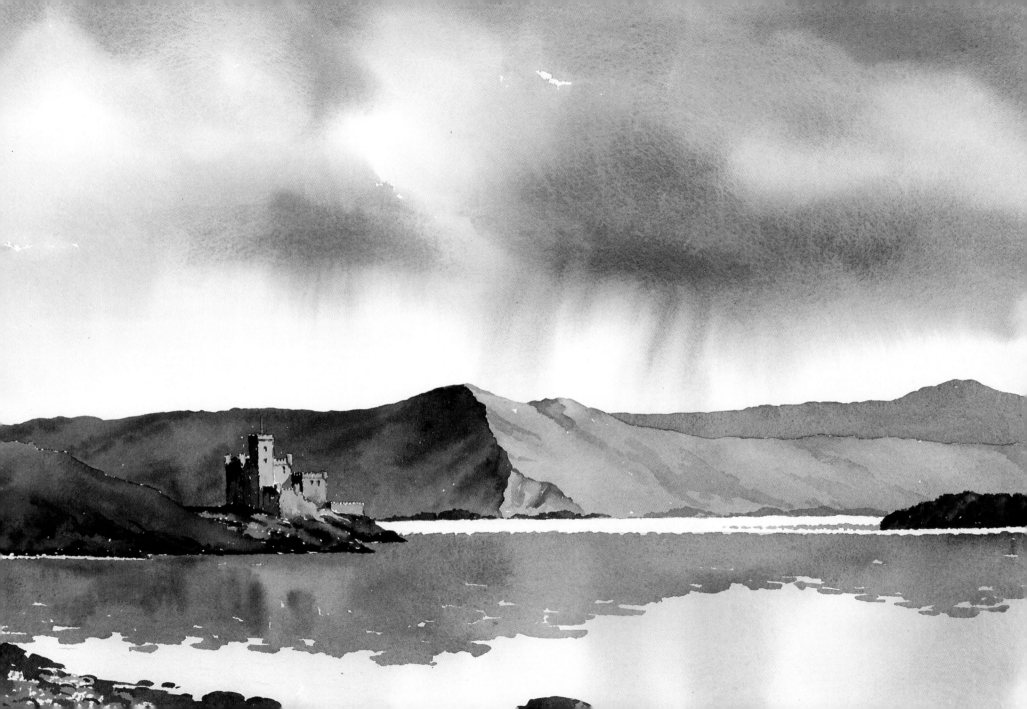

PALETTE

RAW SIENNA
BURNT SIENNA
LIGHT RED
FRENCH ULTRAMARINE

PAPER

ARCHES 300LB (640GSM)
ROUGH

BRUSHES

THREE 1IN (2.5CM) FLATS
NO.12 AND NO.6 SABLES

THE MORDACH ESTUARY

Brush and ivory black

In this painting of a river estuary nature was in a gentler mood and the atmosphere is one of peace and tranquillity, emphasised by the expanse of calm water. There are tonal contrasts, but they are far less dramatic than those in the previous painting. There are, however, marked textural contrasts, with the rough and rocky shingle of the foreshore acting as a foil to the smooth treatment of the water and the distant Welsh mountains in the background.

I normally begin with the sky because this influences every other part of the painting. Here the pale area just above the mountain range was very dilute raw sienna and an even weaker wash served for the areas of sunlit clouds. The cloud shadows were a mixture of french ultramarine and

The blue-grey of the peak stands out strongly against the pale sky

light red, and as we have noticed before, the light red has bled a little to provide a warm edge to the shadows. The blue of the sky was a wash of french ultramarine and this helps to give shape and form to the upper margin of the clouds. These three washes were applied in quick succession so that much blending occurred, but some hard edges remain where the paper was left dry. This mixture of hard and soft edges adds a liveliness which is lost if the whole of the sky area is moistened before the washes are applied.

The foreground shingle was a broken wash of raw and burnt sienna and french ultramarine, with shadows and texturing added in a strong mixture of french ultramarine and light red.

LOOK FOR TEXTURAL CONTRASTS AS WELL AS TONAL CONTRASTS

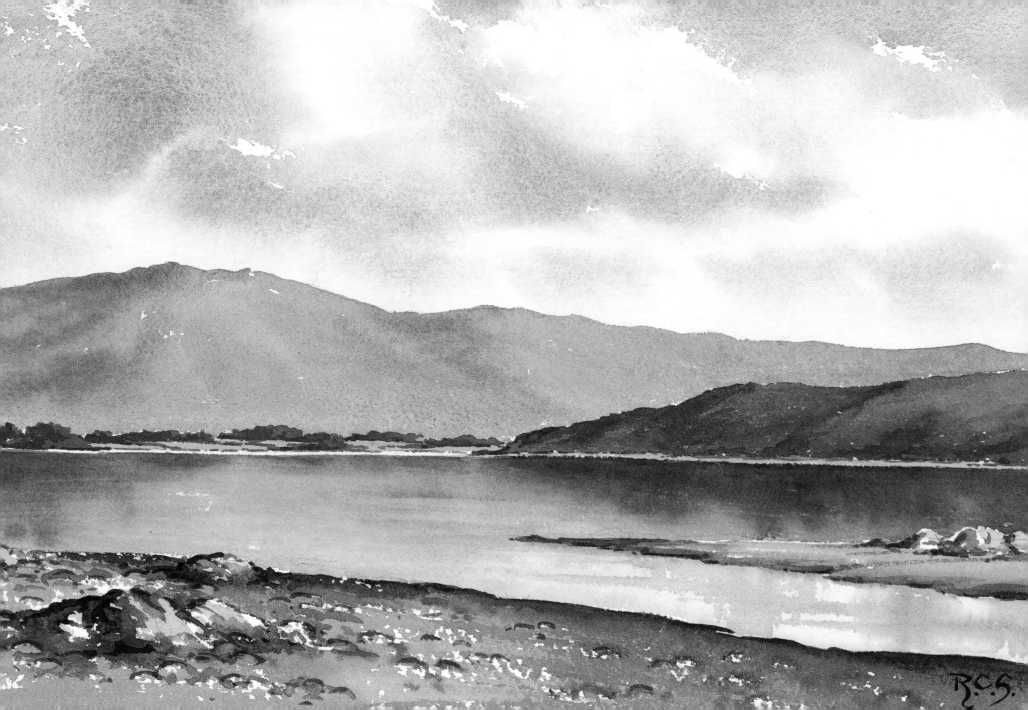

THE FAR CUILLINS, SCOTLAND

Many painters experience difficulty with the perspective of rivers and streams, so that the water sometimes appears to be flowing uphill. The problem is a real one because there is no perspective construction to help them, and the only answer is careful observation and a determination not to put brush to paper until it has been solved.

Painting moving water presents a real challenge for its very movement makes detailed analysis that much more difficult. It always pays to simplify, for any laboured treatment makes the water look static. In this painting the light was catching the stream which consequently looked much lighter in tone than its adjacent banks, and I intentionally exaggerated this contrast, leaving the white of the paper to do much of the work.

I normally paint skies in one quick operation but in this I added some extra cloud shadow on the right, once the initial wash was dry, for greater

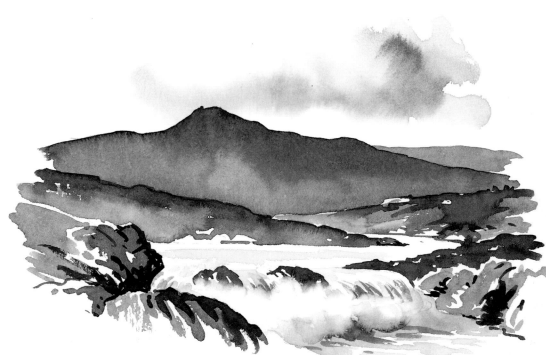

Brush and ivory black

emphasis. The dramatic outline of the mountain makes a strong statement against the pale sky, and here I used a wash of french ultramarine and light red, cooler at the top and warmer below, and with shadows added, wet-in-wet, with a stronger version of the same mixture. I then increased the proportion of light red for the nearer land forms to suggest the presence of heather, with touches of green here and there (raw sienna and Winsor blue).

The pale tones of the stream carry the eye into the heart of the painting

WORKING QUICKLY WITH LIQUID WASHES
ON ROUGH PAPER LEAVES MANY SPECKS OF
WHITE, UNTOUCHED PAPER. DO NOT
WORRY ABOUT THIS – IT CAN ADD SPARKLE
TO A PAINTING

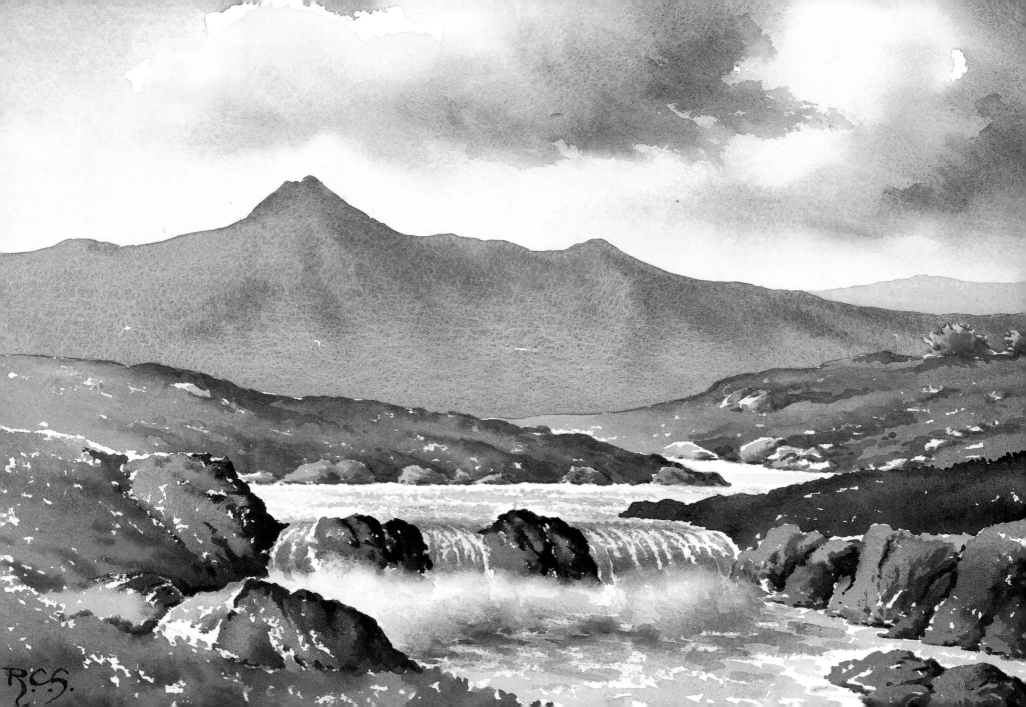

PALETTE

RAW SIENNA
BURNT SIENNA
LIGHT RED
FRENCH ULTRAMARINE
WINSOR BLUE

PAPER

ARCHES 300LB (640GSM)
ROUGH

BRUSHES

TWO 1IN (2.5CM) FLATS
NO.12, NO.8 AND NO.6
SABLES

NEAR KILLARNEY

It was an evening in late autumn in Ireland, with a strong amber light coming from the west casting long shadows over the level fields. It caught the whitewashed cottages and made them stand out dramatically against the looming mass of mountain behind. There was a marked textural difference between the crisp tonal contrasts of the foreground and the soft mistiness of the background. These elements attracted me to the scene, so I decided to feature them prominently.

I began by applying a wash of raw sienna with a touch of light red to the sky and carried this right down to the tops of the cottages and the lines of scrub between them. Into this I painted, wet-in-wet, the grey clouds with horizontal

Brush and ivory black

The pale tones and crisp treatment of the cottage are in contrast with the softer, darker handling of the background

strokes of a large brush loaded with a mixture of french ultramarine and light red. A stronger version of this wash, with a higher proportion of the blue, served for the mountain, and because the background was still moist, this, too, was soft-edged. I then painted in the trees with a blend of burnt sienna and french ultramarine, and because drying was imminent, the outlines, although soft-edged, were more precise, as intended.

I used the white of the paper and very pale washes for the sunlit cottages to maximise tonal contrast with the sombre background, and took care to preserve the light catching the tops of the stone walls. Broken horizontal washes and strong foreground shadows completed the painting.

MAKE SURE YOU EMPHASISE THOSE ASPECTS OF THE SCENE THAT FIRST MADE YOU WANT TO PAINT IT

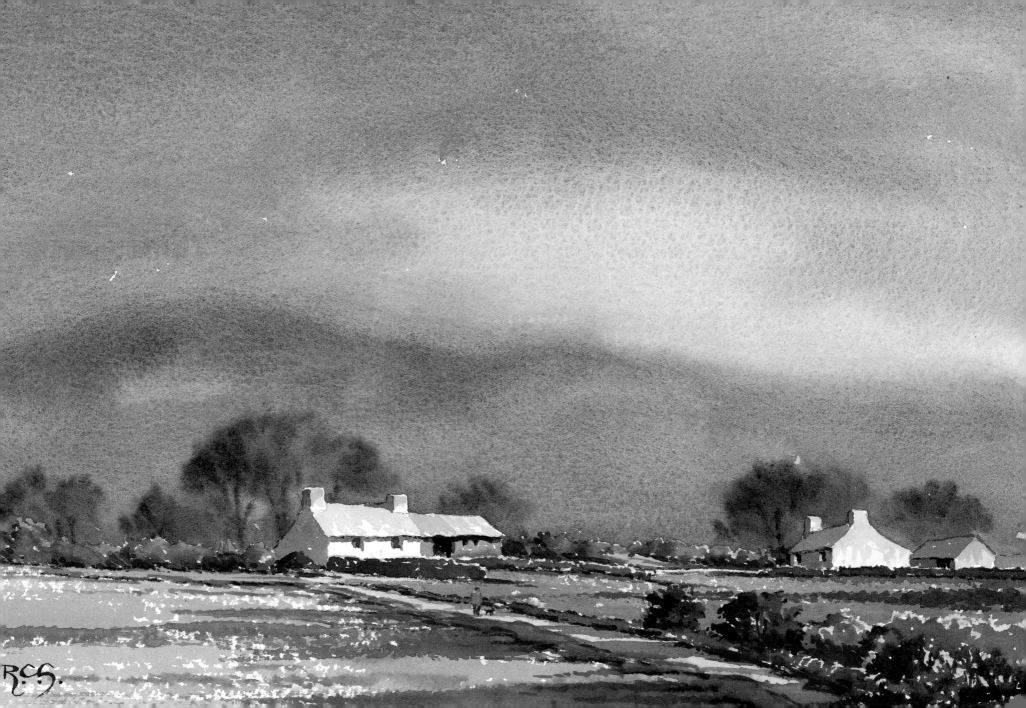

PALETTE

BURNT SIENNA
LIGHT RED
FRENCH ULTRAMARINE
PAYNE'S GREY

PAPER

ARCHES 300LB (640GSM)
ROUGH

BRUSHES

TWO 1IN (2.5CM) FLATS
NO.10 AND NO.6 SABLES

IN THE AUSTRIAN ALPS

These mountains cannot compete with Mont Blanc for altitude or the Matterhorn for dramatic form, but they have a unique beauty of their own. This painting is based on a sketch I made some years ago, but my recollection of the scene is still vivid as the crest and sharp ridge of snow-capped mountain rose majestically above the clouds. Although there were storm clouds about, there were also breaks which gave rise to brilliant tonal contrasts and these I have emphasised.

The buttress on the left provides compositional balance for the mountain peak to the right of centre, while the pale cloud on the left echoes the lower cloud on the right. There are strong tonal contrasts in all parts of the painting, notably the snowy peak against the dark cloud, the right-hand ridge against the pale sky and the climbers and the rocky foreground against the lower cloud.

The sky went in first with a strong mixture of french ultramarine and light red for the dark clouds, with Payne's grey in places for added emphasis. The paler clouds were pure water and I allowed these washes to run together, while diagonal brush strokes on the wet surface indicated distant rain squalls. The line of sunlit snow was just the white of the paper, and french ultramarine and a very little light red were just right for the snow shadows. I used a much stronger mix of the same colours for the rocky outcrops, and with added burnt sienna for the foreground.

Brush and ivory black

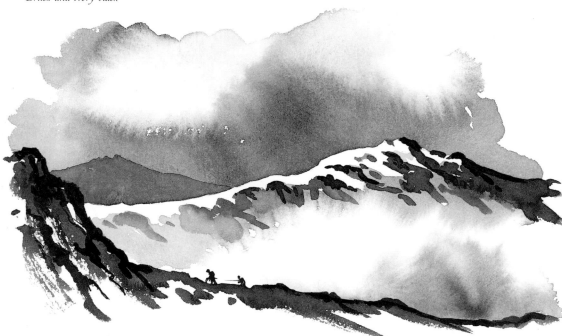

The dark ridge contrasts dramatically with the paler sky behind

WATERCOLOUR IS PERFECTLY CAPABLE OF MAKING POWERFUL STATEMENTS. EVEN THE DEEPEST TONES WILL NOT BE MUDDY IF THEY ARE CORRECTLY APPLIED

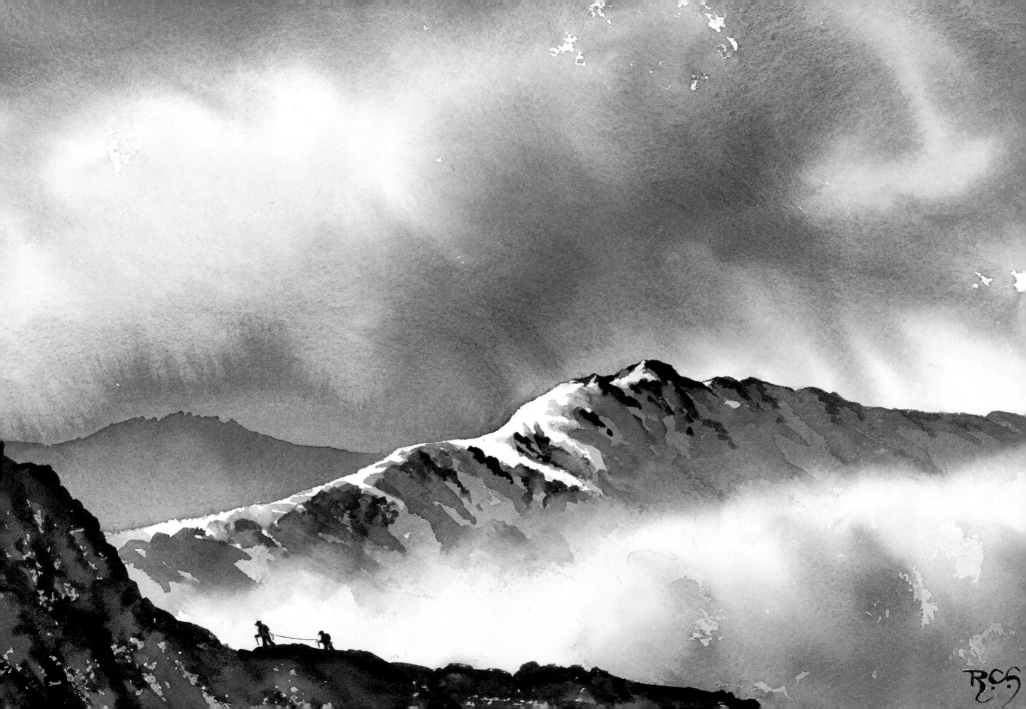

AUTUMN IN COUNTY KERRY, IRELAND

PALETTE

RAW SIENNA
BURNT SIENNA
LIGHT RED
FRENCH ULTRAMARINE
WINSOR BLUE

PAPER

ARCHES 300LB (640GSM)
ROUGH

BRUSHES

THREE 1IN (2.5CM) FLATS
NO.10 AND NO.8 SABLES

This is an altogether softer and more domestic scene than that featured in the previous painting, with the mountain only occupying a small space. However, it still serves as effective compositional balance for the little whitewashed cottage and as a foil for the adjacent autumnal tints. The painting is, indeed, largely a study in blue-greys and warm browns. Despite the more gentle treatment, there are still some strong tonal contrasts, notably the mountain against the pale sky and the cottage against the background of russet foliage. The track leads the eye into the centre of the painting and the farm gate carries it to the brown hillside and distant mountain beyond.

The soft cumulus clouds help to establish the mood of the painting, and were painted with palest raw sienna for the sunlit areas and a liquid wash of french ultramarine and light red for the shadows. The blue sky was a blend of french ultramarine and Winsor blue. The trees were a mixture of burnt sienna and light red, with french ultramarine added for the shadows, and were painted with some hard edges and some soft. The sunlit cottage was handled in pale tones, in places using just the white of the paper, and there is a suggestion of reflected light in the lower part of the gable end. Broken washes of raw sienna and a little Winsor blue depicted the rough grass, and the reflections in the pond were painted, wet-in-wet, in colours similar to those of the objects above.

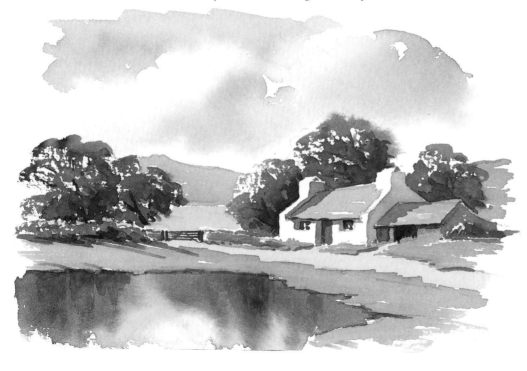

The whitewashed wall registers strongly against the dark autumn foliage

Brush and ivory black

YOUR FIRST OBSERVATION SHOULD BE THE DIRECTION OF THE LIGHT, AND YOU SHOULD MAKE SURE IT REMAINS CONSISTENT IN ALL PARTS OF THE PAINTING

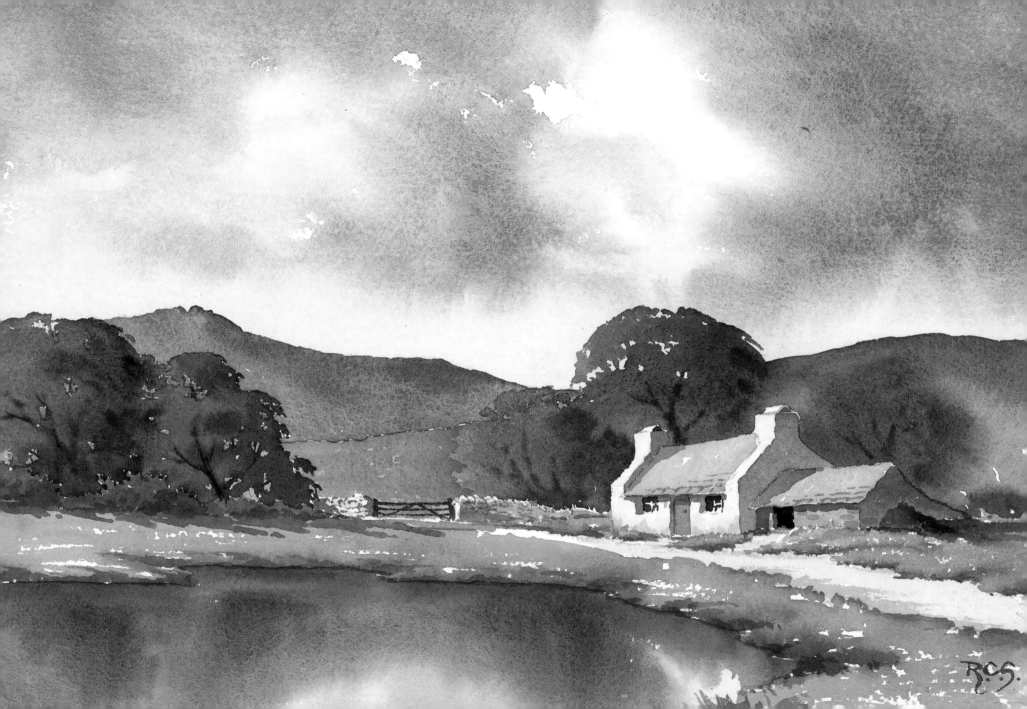

PALETTE

RAW SIENNA
BURNT SIENNA
LIGHT RED
FRENCH ULTRAMARINE
WINSOR BLUE

PAPER

ARCHES 300LB (640GSM)
ROUGH

BRUSHES

THREE 1IN (2.5CM) FLATS
NO.12 AND NO. 6 SABLES

BOATHOUSE, DERWENTWATER

Brush and indian ink

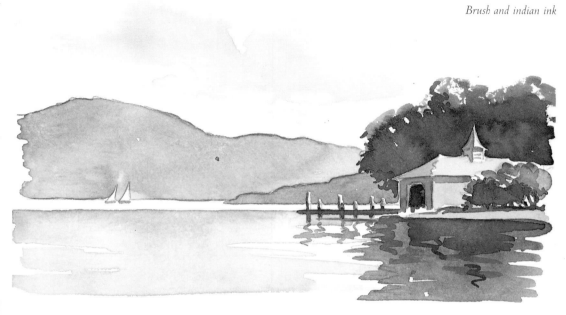

The English lakes have an irresistible charm of their own, and for me, they still hold the magic I first experienced during happy childhood holidays long ago. However, with attractive subject matter at every turn, it is all too easy to paint anything and everything, and to forget about such matters as good composition and well chosen focal points. In this painting of Derwentwater, the little brick-built boathouse makes a useful centre of interest. Its warm red colour stands out pleasantly against the predominantly green surroundings — this is the attraction of complementary colours placed side by side — and its pale tone contrasts with the deeper tones of the adjacent trees and their reflections. It is off centre to the right of the composition and is balanced by the mountain to the left. Notice how the outline of this range carries the eye towards the centre of interest.

I painted the sky in one quick operation, carrying the pale, warm colour down to the water line. Its light tone enabled me to paint the line of hills over the top, also in one operation, using raw sienna with a touch of Winsor blue for the green and french ultramarine with a dash of light red for the shadows, and allowing the two washes to blend together. The distant stretch of pale, wind-ruffled water serves the purpose of separating the hills from their soft reflections below. The foreground features were painted more strongly, to bring them forward, and their reflections were given hard, indented edges to indicate ripples.

This mountain mass helps to balance the boathouse on the right to provide compositional harmony

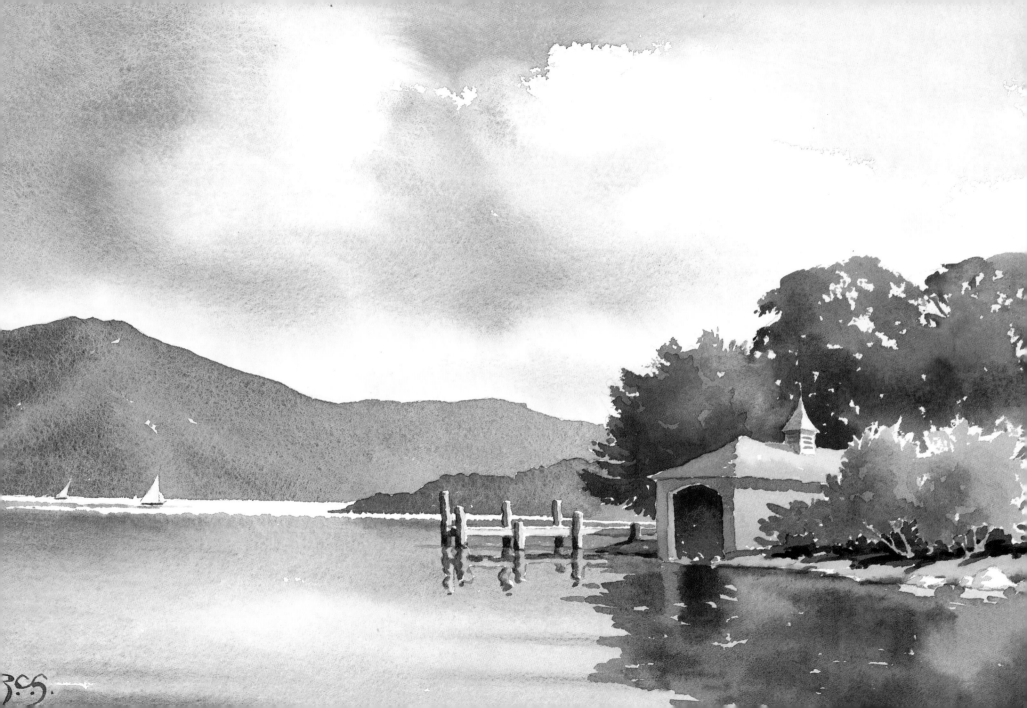

PALETTE

RAW SIENNA
BURNT SIENNA
LIGHT RED
FRENCH ULTRAMARINE
WINSOR BLUE
PAYNE'S GREY

PAPER

ARCHES 300LB (640GSM)
ROUGH

BRUSHES

1IN (2.5CM) FLAT
No.12, No.10 AND No.6
SABLES

THE MOUNTAINS OF MOURNE, IRELAND

Pen, brush and indian ink

This is the sort of natural composition that is a gift to the artist. The cottage in its leafy setting is balanced by the looming mass of misty mountain, and the track curves into the centre of the painting, to the small figure and dog which constitute the focal point. The line of trees on the right and the stone wall and rough hedge on the left carry the eye in the same general direction. There is plenty of counterchange, with the pale tones of the cottage contrasting strongly with the much deeper tones of the surrounding trees and bushes. These trees, with their crisp outlines, also stand out starkly against the much softer treatment of the background hills.

I began by applying a pale wash of raw sienna to the whole of the sky area, and carried it down to the cottage and the further margin of the foreground grass. I then painted the clouds, wet-in-wet, with a mixture of french ultramarine and light red. The mountains went in next with a slightly stronger version of the same wash, merging softly into pale green for the valley floor. While this wash was still wet, I lifted out the two shafts of sunlight with a No.10 brush. When everything had dried I added a few lines of grey to suggest the drystone walls in the valley.

I painted the cottage and other foreground features more strongly to contrast with the misty treatment of the background.

The man and his dog provide a focal point

SHAFTS OF SUNLIGHT CAN SUGGEST A BREAK IN THE CLOUDS AND ADD INTEREST TO THE SCENE BELOW, BUT THEY NEED TO BE HANDLED WITH RESTRAINT

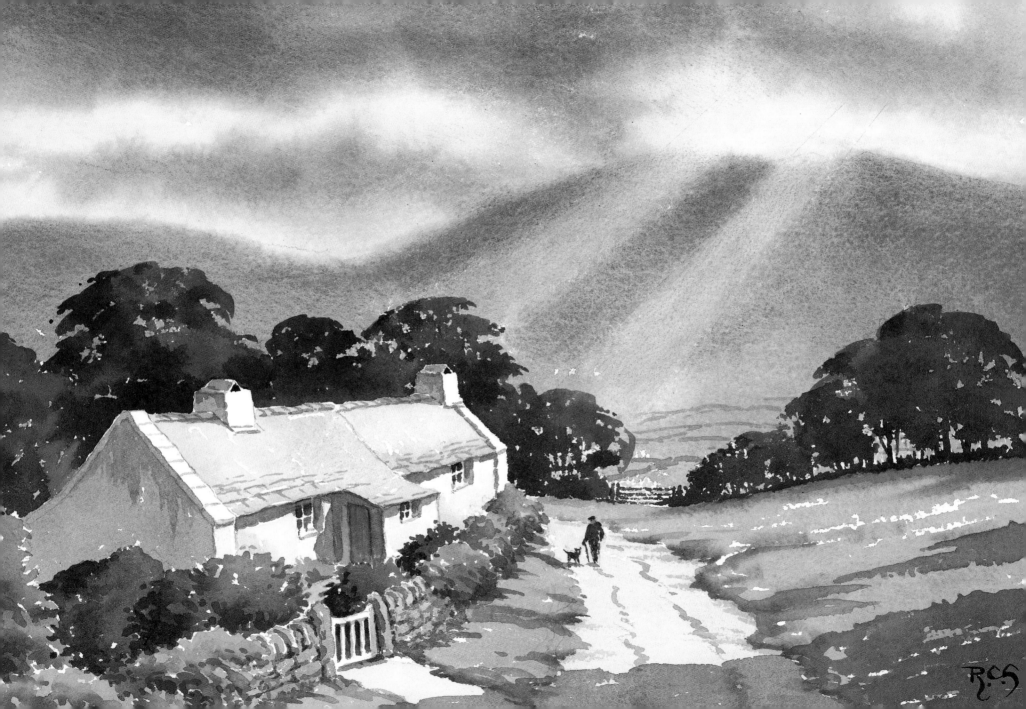

RIVERSCAPES

*R*ivers have an irresistible fascination, not only for their diversity and marvellous reflections but also for the intriguing manner in which they wind their way into the heart of the landscape. Finding the right spot for a painting is of course crucial, for we need to ensure they do in fact carry the eye into the painting and not straight out of it!

In the countryside, very little detailed sketching will be necessary, as fluent brushwork will capture the form and texture of foliage and grass – however, careful drawing of the river margins is essential. We have all seen riverscapes in which the water appears to be flowing uphill, and this can be a real problem for the inexperienced for there is no perspective construction to come to their aid. The only answer, as with so much in art, is careful observation and the determination not to proceed until the water surface has been persuaded to lie flat.

Urban riverscapes, with their bordering warehouses, wharfs and other buildings, call for more detailed sketches, particularly if bridges and boats – both tricky subjects to draw – figure in the composition.

The success of most river paintings depends largely on the competent and effective handling of reflections, and we should plan our strategy carefully before putting brush to paper. Any alteration in painting water is almost as fatal to success as it is in painting skies!

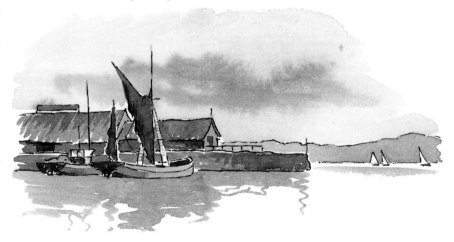

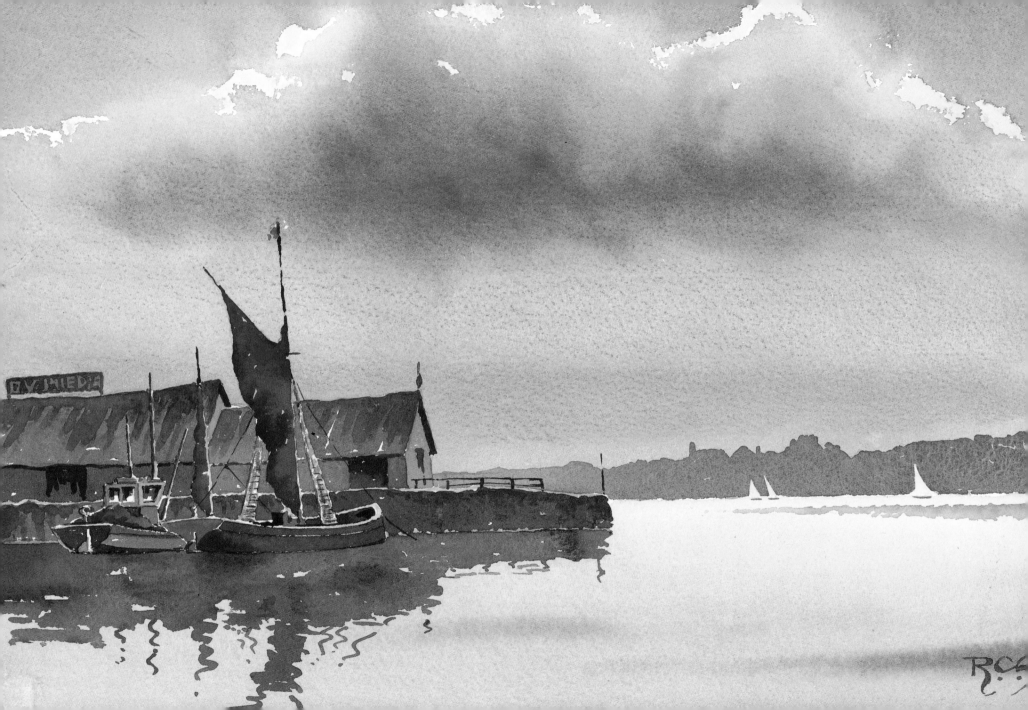

PALETTE

RAW SIENNA
BURNT SIENNA
LIGHT RED
FRENCH ULTRAMARINE
PAYNE'S GREY

PAPER

ARCHES 300LB (640GSM)
ROUGH

BRUSHES

TWO 1IN (2.5CM) FLATS
NO.12 AND NO.8 SABLES

Brush and ivory black

MISTY RIVER

For the water I applied pale washes similar to those used for the sky, painting around the outline of the landing stage and then dropping in the reflections of the trees, wet-in-wet, with rapid, vertical brush strokes. A quick indication of the foreground rushes completed the painting.

The landing stage at left stands out crisply against the soft reflections behind

Watercolour is the perfect medium for capturing the effects of light, mist and reflections in still water. All these elements were present in this estuary scene and I determined to try to reflect them in a quick, spontaneous painting and not worry at all about detail. It is the labouring after precision and literal accuracy that so often slows the painting process and contributes to the loss of feeling and atmosphere.

I began by applying a very pale wash of raw sienna to the paper, adding a dilute mixture of french ultramarine and light red to the upper part of the sky and a slightly stronger wash of the same blue-grey for the distant, misty land mass. I increased its strength towards the right of the paper to indicate that the light was coming from the left. The tops of the trees were shrouded in low mist so I painted them in quickly before the paper had dried, using various combinations of raw sienna, burnt sienna and Payne's grey. I left a ragged edge at the base of the large tree on the right to accommodate a bank of reeds which I put in later, and added the willow trunks and the river bank below the more distant trees on the left.

ATMOSPHERIC EFFECTS ARE BEST CAPTURED BY LIQUID WASHES AND WET-IN-WET TECHNIQUES

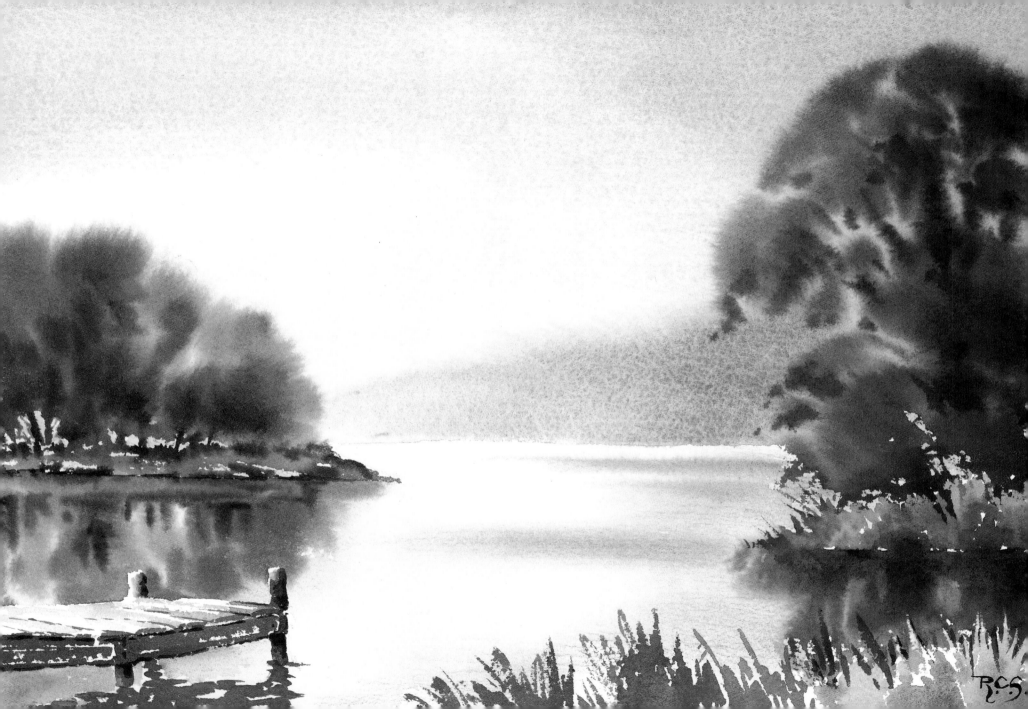

PALETTE

RAW SIENNA
BURNT SIENNA
LIGHT RED
FRENCH ULTRAMARINE
WINSOR BLUE

PAPER

ARCHES 300LB (640GSM)
ROUGH

BRUSHES

THREE 1IN (2.5CM) FLATS
NO.12, NO.10 AND NO.6
SABLES

CORNISH ESTUARY

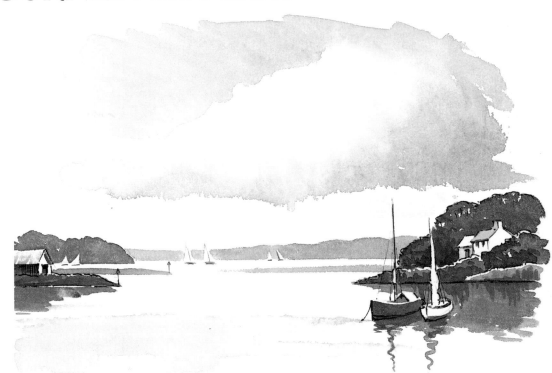

The sinking of the land millions of years ago led to the flooding of the lower reaches of rivers by the sea, and thus to the broad river estuaries that are a feature of the Devon and Cornwall coastline. Here, the lively mass of cumulus cloud demanded particular attention, and it persuaded me to adopt a low horizon in order to do it full justice. The sunlit area of the cloud was pale raw sienna with a touch of light red while its shadow was french ultramarine and light red, with the proportion of light red increasing for the warmer greys lower down. The blue of the sky was french ultramarine at the top, and Winsor blue with a little raw sienna just above the horizon. When all this was dry I added more of the same grey to emphasise the form of the clouds.

The far shore of the estuary was a wash of

Fibre-tip pen and wash

Small triangles of white left in the background wash indicate distant sails

french ultramarine with a very little light red, decreasing in tone to the left to suggest recession, and I left four little triangles of white to indicate sails. I know sails come in *all* colours these days, but I still prefer the white variety — and, of course, the russet sails of sailing barges.

The creamy colour of the cloud was reflected in the smooth waters of the estuary, with a hint of the cloud shadow in the foreground. The nearer land forms, buildings and moored boats were mostly painted in stronger, warmer colours to ensure they 'came forward', while the cooler, background colours receded to create aerial perspective.

A DISTANT, RECEDING SHORELINE CAN OFTEN BE REPRESENTED BY A BLUE-GREY WASH WHICH PALES AS THE DISTANCE INCREASES

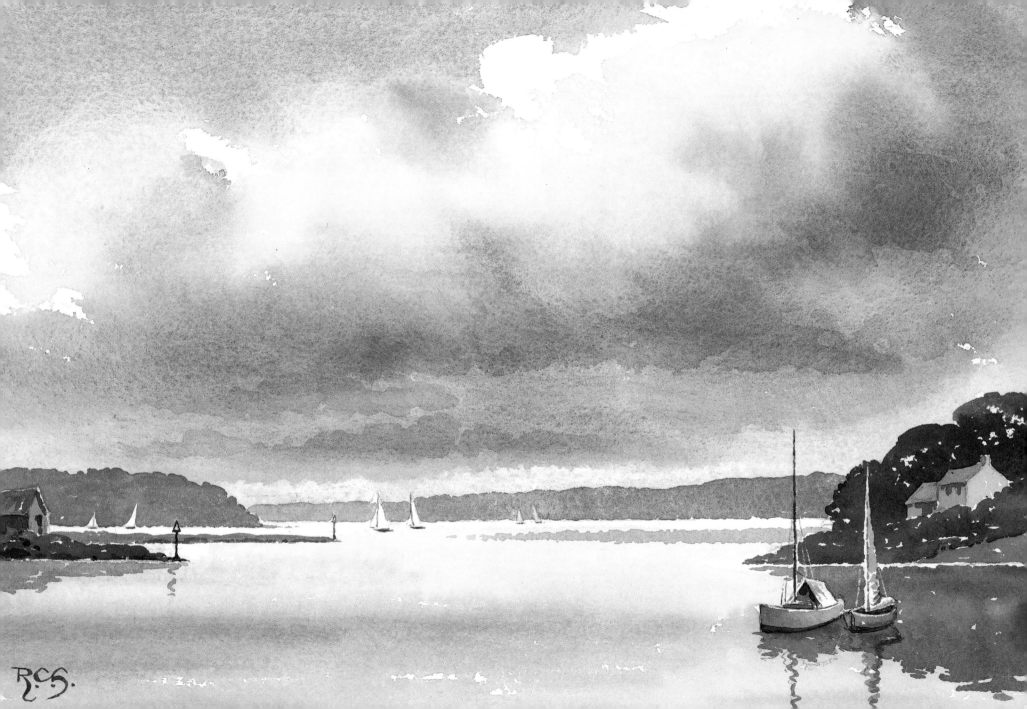

PALETTE

RAW SIENNA
BURNT SIENNA
LIGHT RED
FRENCH ULTRAMARINE
WINSOR BLUE

PAPER

ARCHES 300LB (640GSM)
ROUGH

BRUSHES

THREE 1IN (2.5CM) FLATS
NO.12 AND NO.8 SABLES

THAMES LANDING STAGE

The upper reaches of the River Thames run through delightful and mostly well wooded country to provide many an attractive subject for the artist. As with all riverscapes, the success of the painting depends primarily upon the treatment of the water – does it capture its limpid movement, or is it laboured and unconvincing? The trouble with water is that it will not stay still and allow us to analyse at leisure all the forms and colours of its reflections. Many painters use photographs, which can freeze a moment in time, to get over this difficulty, but that is never as satisfactory as being on the spot. The best answer, as always, is thorough observation and the memorising of recurrent forms. Alteration and overworking will destroy the lively portrayal of water and should be avoided. It makes sense to plan your strategy and then keep to it – and avoid vague experimentation on your watercolour paper.

Here there was a stretch of wind-ruffled water by the bend in the river and as this appeared very pale in tone, it served the useful purpose of separating the far river bank from its reflection. The next problem was how to paint these reflections, which were made up of millions of tiny ripples – far too many for the watercolour medium to cope with. The only solution was to paint soft-edged reflections and reserve the hard-edged ripples for the foreground, where they appeared sufficiently large to justify individual treatment.

The indented edges of reflected forms suggest a rippled surface

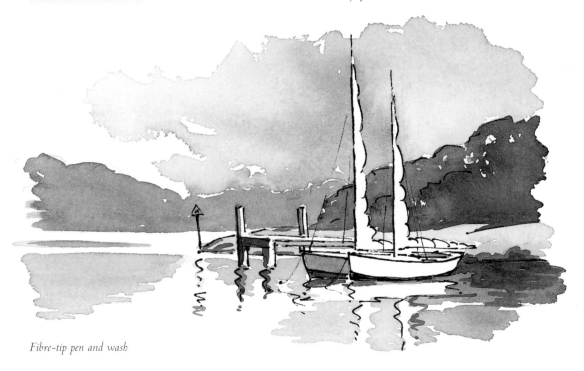

Fibre-tip pen and wash

REMEMBER THAT RIPPLES ALSO OBEY THE LAWS OF PERSPECTIVE AND APPEAR SMALLER AS THEY RECEDE

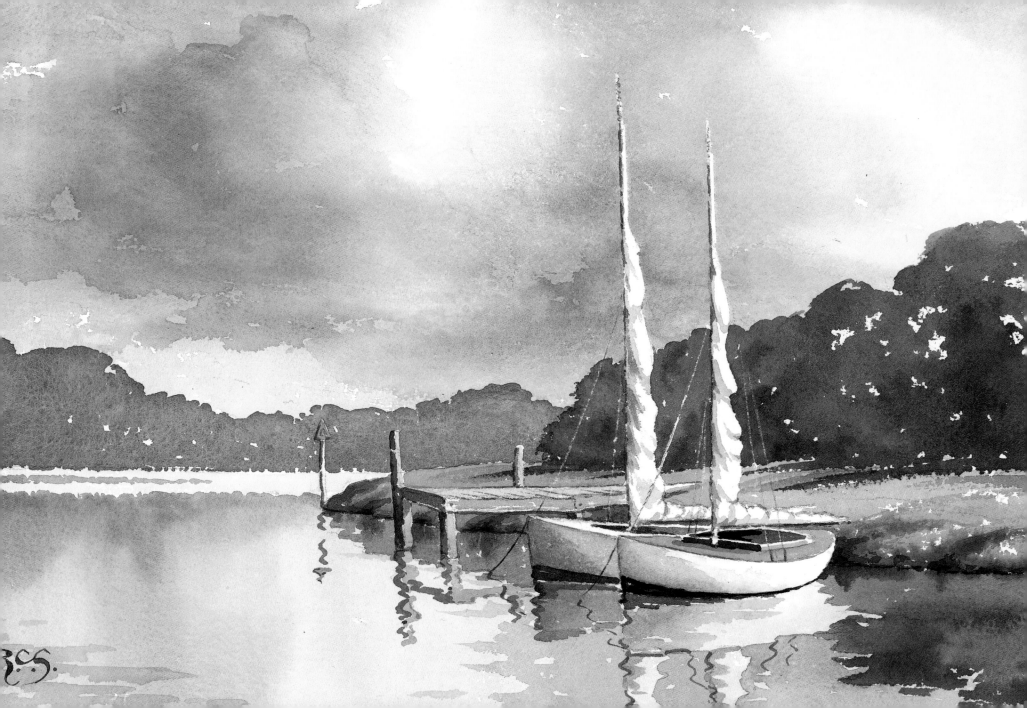

THE BLACKWATER ESTUARY

At the attractive little town of Maldon, Essex, the River Blackwater broadens out to form an estuary, with many a pleasing vista to tempt the artist. This view has much to commend it, although I must confess that I have reduced the number of buildings and boats for the sake of simplicity. The church tower is something of a landmark and provides a useful vertical in a mainly horizontal composition. It is balanced by the sailing barge and its reflection on the right. The moored yachts and the rough, grassy bank behind them provide some foreground interest.

The early evening sky was cloudless and spread a pale, golden light over the scene below. I used a dilute wash of raw sienna, starting on the right, the direction from which the light was coming, and adding a little light red and then french ultramarine as I carried the wash to the left. Because this wash was very pale, I was able to paint the buildings and trees over it without difficulty.

The waters of the estuary took their colours from the sky except for two areas of disturbed

The church tower and trees make a strong statement against the pale sky

water which showed up as horizontal swathes of deeper colour. In order to accentuate the pale glow of sky and water and make them shine, I painted the buildings, trees and boats in fairly deep tones. This had the desired effect and also produced those useful tonal contrasts which breathe life into a painting.

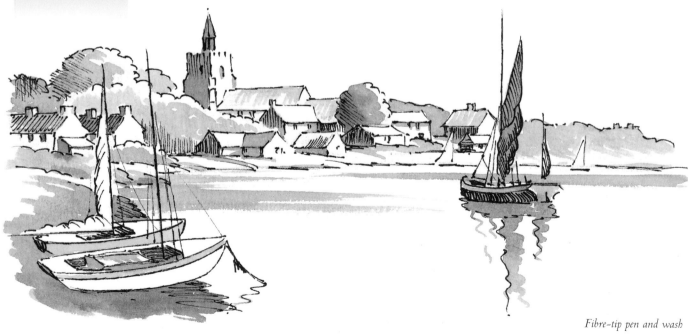

Fibre-tip pen and wash

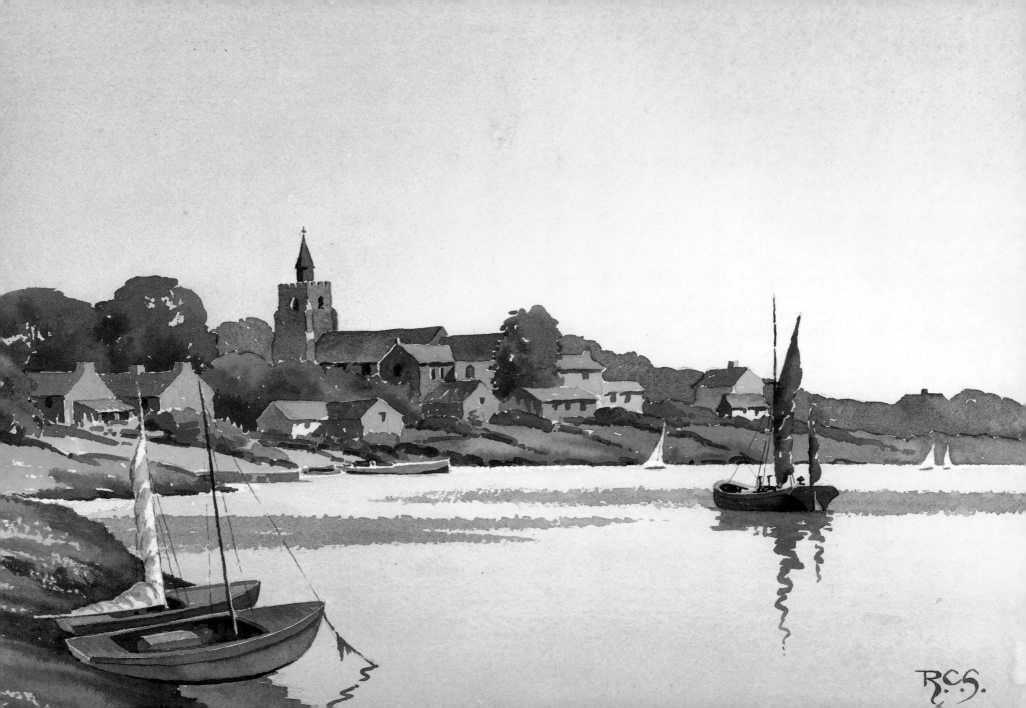

WOODLAND RIVER

Many people are put off attempting woodland scenes by the mass of leaf and twig detail that confronts them. Any attempt to produce a literal copy of the subject, exact in every detail, is bound to result in over-elaboration and a tired, overworked painting from which freshness and clarity have been lost. This is where imagination and drastic simplification should come into play. If you look at your subject through half-closed eyes, the mass of detail merges into larger areas of varying tone and colour and it is these that you should try to paint.

Having chosen my spot, I quickly sketched in the trunks of the four nearer trees. I wanted these to stand out boldly against their background, so I applied masking fluid to them. I then covered the whole of the paper above the stretch of water with

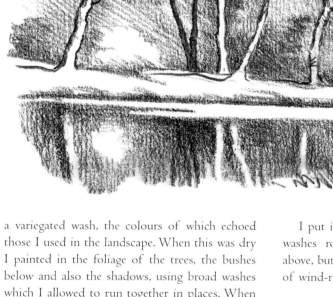

Conté pencil

The nearer trunks stand out boldly against the shadowy background

a variegated wash, the colours of which echoed those I used in the landscape. When this was dry I painted in the foliage of the trees, the bushes below and also the shadows, using broad washes which I allowed to run together in places. When the paper was again dry, I rubbed off the masking fluid, leaving the white silhouettes of the tree trunks. I painted these in pale tones and added much darker shadows, using the same dark wash for the branches, the more distant tree trunks and the foreground shadows.

I put in the deep-toned reflections next, with washes roughly corresponding to the colours above, but leaving a pale strip to suggest a stretch of wind-ruffled water.

STRIVE TO REDUCE THE COMPLEX DETAILS OF WOODLAND SCENES TO MASSES AND THEN PAINT THEM AS BROAD AREAS OF TONE AND COLOUR

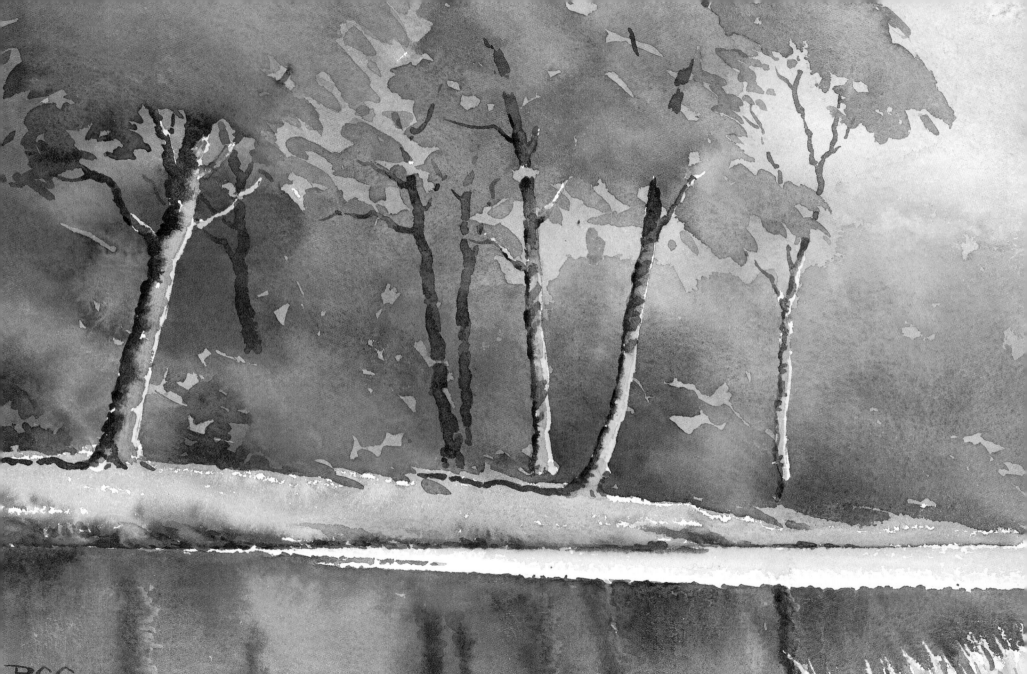

PALETTE

RAW SIENNA
BURNT SIENNA
LIGHT RED
FRENCH ULTRAMARINE
WINSOR BLUE
PAYNE'S GREY

PAPER

ARCHES 300LB (640GSM)
ROUGH

BRUSHES

1IN (2.5CM) FLAT
NO.12, NO.8 AND NO.4
SABLES

BIRCHES BY A STREAM

This is another painting of a small river in a woodland setting, but the season is winter and the trees have shed their leaves. I wanted the trunks to stand out against the misty background, particularly as the trees were silver birches with their whitish barks, so I again used masking fluid to preserve them. When this was dry I applied a variegated wash to the whole of the background area, pale Winsor blue at the top shading down to raw sienna. While this was still wet I painted in the misty shapes of the more distant trees, using raw sienna and Winsor blue in various combinations. French ultramarine and light red served for the soft shadows and, in greater concentration, for the darker background tree trunks. These trunks I left till last so that, with the paper beginning to dry, the marks would not spread too much, while still remaining soft-edged.

Once the paper was dry I carefully rubbed off the dry masking fluid, leaving six white tree-trunk shapes. It was then just a matter of painting in the texture with a dry-brush technique and adding the shadows. I used a No.4 rigger for the finer branches and twigs.

The grass under the trees was a broken wash of raw sienna with a little Winsor blue added, and once this was dry I painted in the horizontal tree shadows in Payne's grey plus a little raw sienna. The russet-coloured bush acts as a stop to prevent the stream carrying the eye off the paper.

The contrast between the hard-edged and the soft-edged tree trunks helps to suggest recession

Pen, brush and indian ink

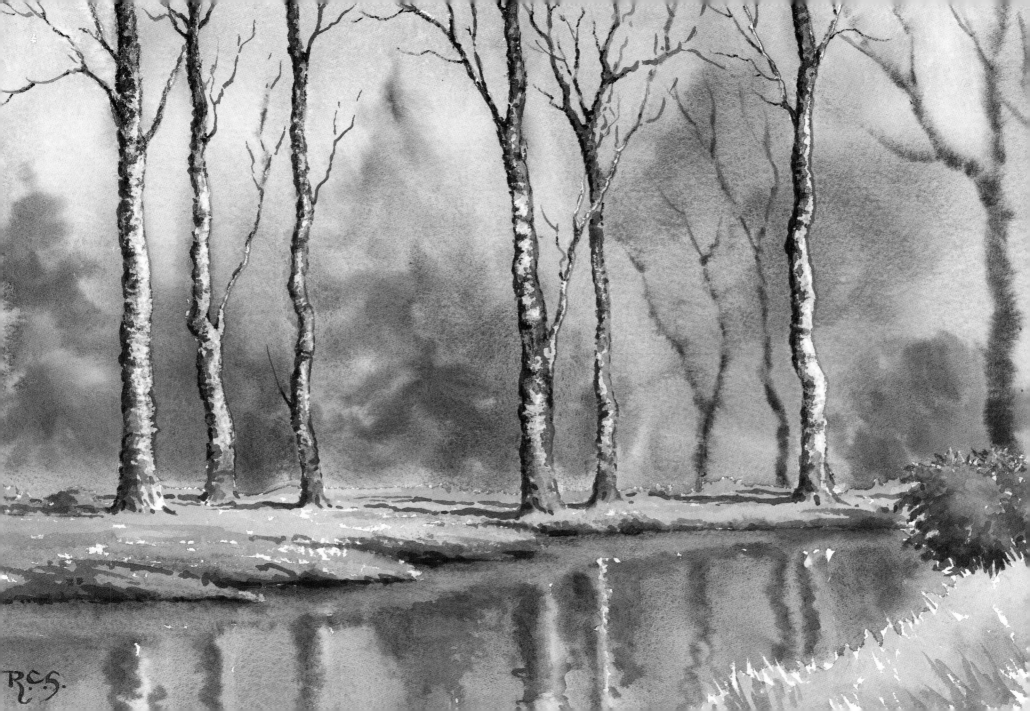

PALETTE

RAW SIENNA
BURNT SIENNA
LIGHT RED
FRENCH ULTRAMARINE
WINSOR BLUE

PAPER

ARCHES 300LB (640GSM)
ROUGH

BRUSHES

TWO 1IN (2.5CM) FLATS
NO.12, NO.8 AND NO.6
SABLES

AUTUMN ON THE AVON

There are many things to consider when choosing a vantage point from which to paint a river scene, with composition naturally high on the list. It always helps if the river curves into the heart of the landscape and does not carry the eye away from it. Balance, too, is important, with objects on each side having roughly equal tonal weight. If there is a good measure of tonal contrast, so much the better for the strength and interest of the resulting painting. The plethora of greens can be a problem, particularly in high summer and it is worth looking for variations in the dominant green, and for other colours.

This spot on the River Avon in Sussex had much going for it from all these points of view. The river meandered right into the painting; the landing stage and trees on the left were balanced by the tall willows on the right, and there was plenty of tonal contrast. As well as warm and cool greens there were the russet tints of autumn and the misty blue-grey of the distant downs.

As the sky occupied only a small area on my paper, I kept the tones pale and the treatment simple. I made the most of the range of colours, exaggerating some for variety, and I also emphasised tonal contrasts — the pale landing stage against the deep reflections is just one example.

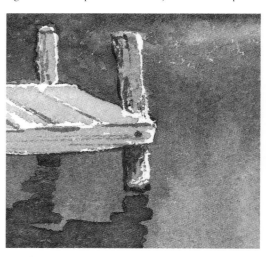

The pale landing stage stands out against the deep-toned reflections

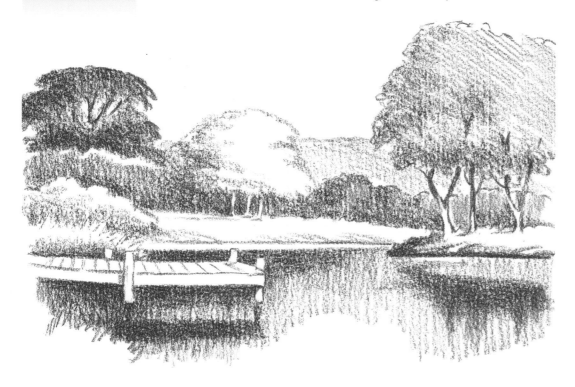

Sepia Conté pencil

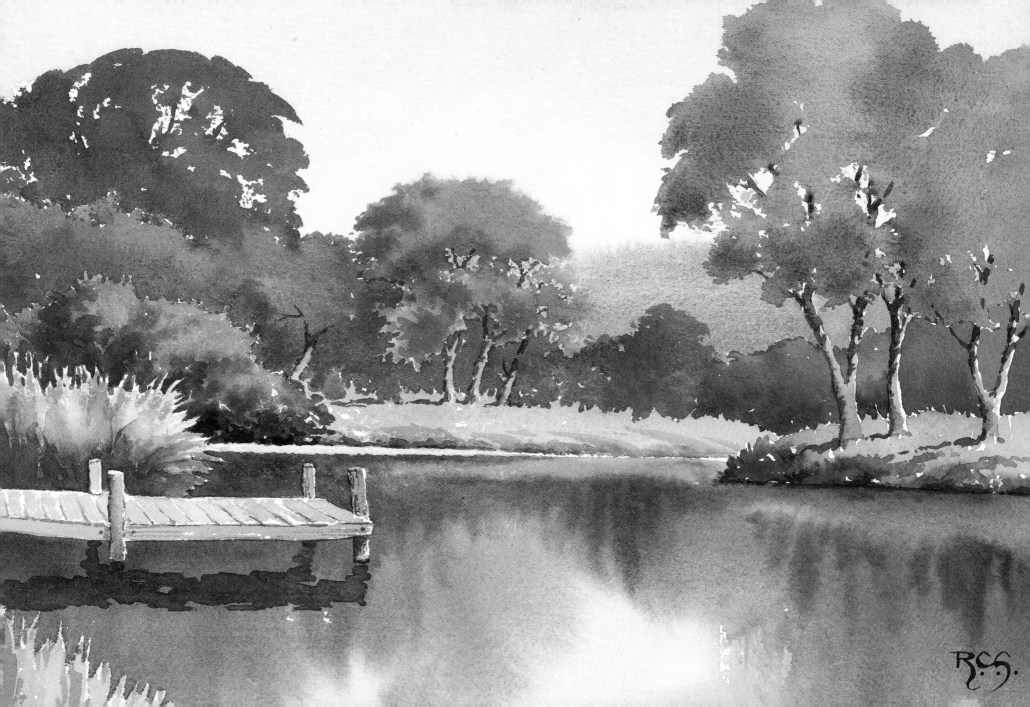

PALETTE

RAW SIENNA
BURNT SIENNA
LIGHT RED
FRENCH ULTRAMARINE
WINSOR BLUE

PAPER

ARCHES 300LB (640GSM)
ROUGH

BRUSHES

1IN (2.5CM) FLAT
NO.12, NO.8 AND NO.4
SABLES

Snow can be extremely helpful in producing strong tonal contrasts which breathe life into a painting. Here the line of snow on the far bank separates the background from its reflection which is very similar in tone and colour, while the foreground snow contrasts with the deeper tones of the water and the riverside scrub.

The tiny area of sky is treated simply, and in warm tones to set the scene for the rest of the painting. I preserved a few tree trunks with masking fluid before applying a variegated wash of burnt sienna, light red and a little french ultramarine for the bank of distant foliage. I added shadows, wet-in-wet, with a mixture of french ultramarine and light red, and still more once the paper had dried, to produce a blend of hard and soft edges.

The differing tones add variety to the treatment of the distant tree trunks

WINTER RIVER

Brush, pen and indian ink

The water was a wash of burnt sienna, light red and french ultramarine, pale on the left, deeper on the right, and to this wet surface I added vertical strokes of green and some much darker grey.

I used a dilute wash of french ultramarine and a touch of light red for the pale shadows in the foreground snow. The skeletal trees were painted with a stronger mixture of burnt sienna and french ultramarine, with a hint of green near the ground. For the twigs I used a No.4 rigger, held towards the end of the handle to produce freer, more rhythmic strokes.

PRACTISE HOLDING A RIGGER NEAR THE END OF THE HANDLE TO PRODUCE LIVELY RHYTHMIC BRUSH STROKES

MEDITERRANEAN LANDS

The sunshine and bright colours of the Mediterranean landscape may call for additions to our palette and will remind us vividly of the French Impressionists' work and their brilliant treatment of light. We, too, should be receptive to the interplay of light and shade, and sometimes be aware of the need to wait until the sun is in the optimum position to maximise its effect.

There is usually a warm, reflected light in the shadows and if you do it full justice, your colours will be rich and vibrant. If the effects of reflected light are ignored, shadows will look flat and dead.

Do your best to avoid working in direct sunlight. The glare on your paper will make the proper evaluation of tone and colour difficult and will also make your washes dry much too quickly. In the warm, dry atmosphere, premature drying can be a real problem, but you will soon learn to add a little more water to your washes to compensate. Another solution would be to add a few drops of glycerine to your water container. If finding shade is not possible, as sometimes

happens, try turning your board so that the sun strikes it at an oblique angle.

As you will see from the next few pages, there is a diversity of subject but a unity of theme – sunshine and shadow.

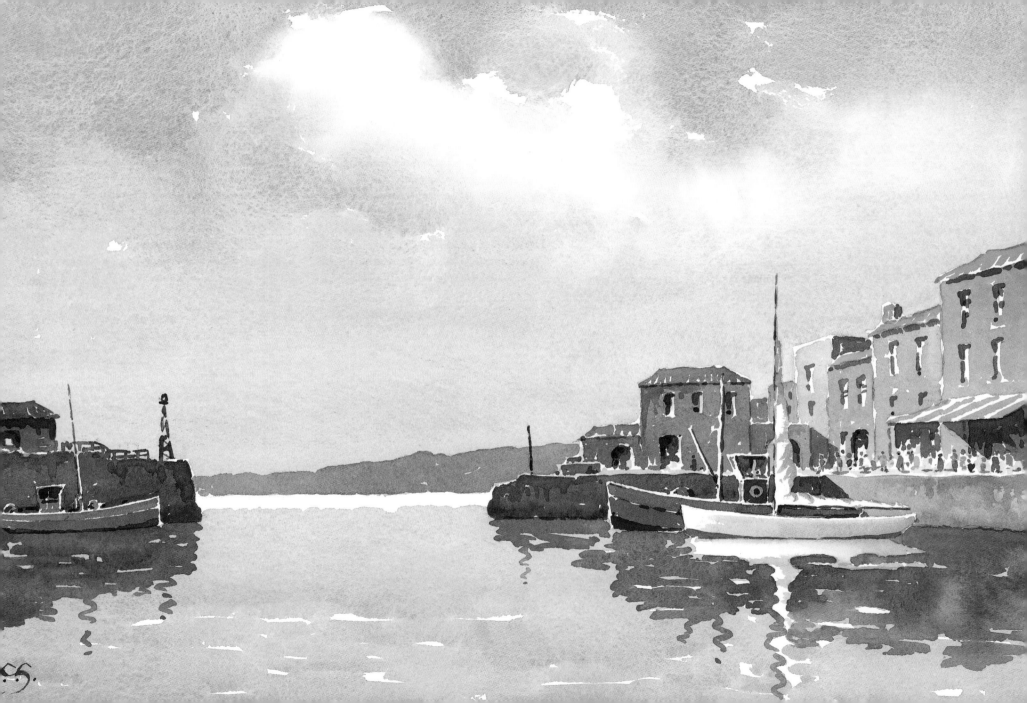

MEDITERRANEAN WATERFRONT

PALETTE

RAW SIENNA
NAPLES YELLOW
BURNT SIENNA
LIGHT RED
FRENCH ULTRAMARINE
WINSOR BLUE

PAPER

ARCHES 300LB (640GSM)
ROUGH

BRUSHES

1IN (2.5CM) FLAT
NO.10 AND NO.6 SABLES
NO.2 RIGGER

This scene is typically Mediterranean with its colour-washed buildings, its Roman tiles, its variety of fishing craft and above all its warm colouring. Today such anchorages are crammed with opulent pleasure craft of all shapes and sizes, but I have dispensed with these and retained the far more interesting working boats, with their solid, no-nonsense lines and their fishing nets hung out to dry.

It often happens with coastal scenes such as this that most of the compositional weight is on one side, and we have to arrange things so that some sort of balance is restored. The distant hills on the left were a start, and I reinforced them with the soft-edged clouds and the moored boats.

There was much detail and it would have been all too easy to have included everything, to the detriment of the overall atmosphere of the scene. A conscious effort has to be made to avoid this pitfall and devise ways of suggesting detail rather than reproducing it literally. The figures on the quayside are just dabs of paint and yet I think

Note the tonal contrasts, the warm, reflected lights and the rough indications of figures on the quayside

Fibre-tip pen and wash

they do the trick. This sort of treatment takes far less time than the meticulous approach and results in a much fresher and more spontaneous painting. It requires some planning and forethought as, for example, in the leaving of white shapes in the shadows cast by the awnings to accommodate those dabs of paint. As always, an eye for colour and an awareness of tonal contrasts are equally important.

DO NOT TRY TO INCLUDE EVERY DETAIL,
BUT CONCENTRATE ON THOSE
THAT CONTRIBUTE TO THE CHARACTER OF
YOUR SUBJECT

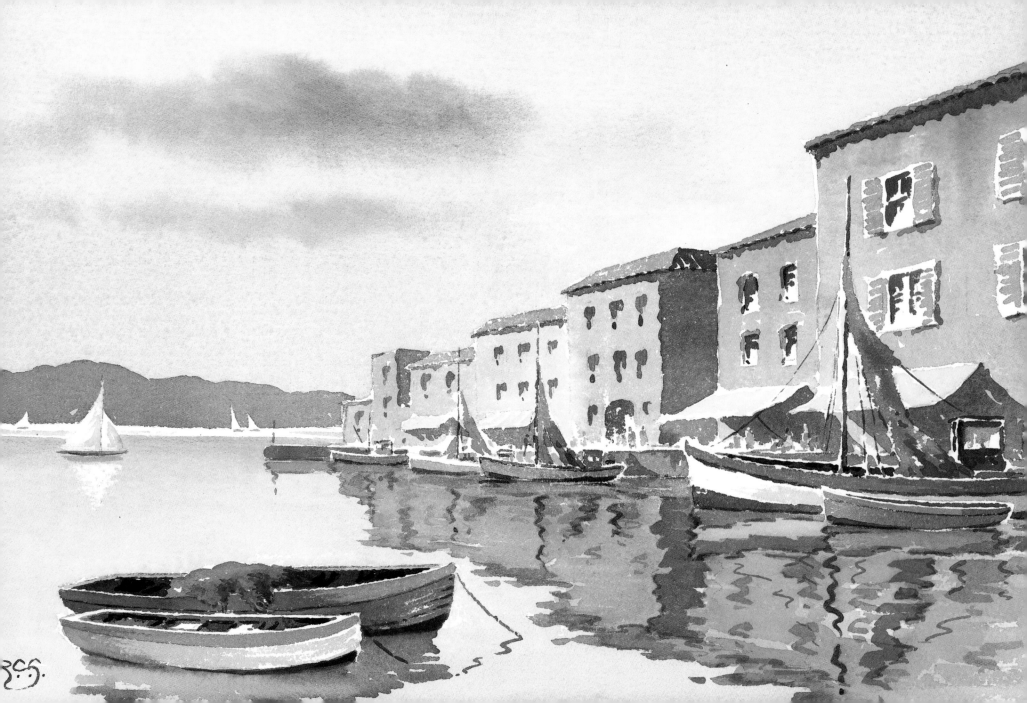

PALETTE

RAW SIENNA
BURNT SIENNA
LIGHT RED
FRENCH ULTRAMARINE
WINSOR BLUE

PAPER

SAUNDERS WATERFORD
300LB (640GSM) ROUGH

BRUSHES

TWO 1IN (2.5CM) FLATS,
NO.12, NO.10 AND
NO.8 SABLES

HILL VILLAGE, PROVENCE

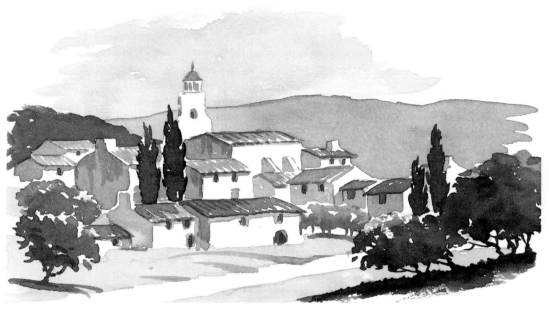

This sun-baked district of southern France abounds in attractive subject matter, as painters have discovered over the ages. The many hill villages, with their pantiled houses clustering around the village church, provide delightful compositions. In this painting I omitted some of the houses for the sake of simplicity, and balanced the prominent church tower with the strongly painted foreground trees on the right. The angle of the sun is just right and produces plenty of sunlit and shadowed elevations, which help to give the buildings a three-dimensional appearance. The strong verticals of the deep grey-green cypresses act as a foil to the mainly horizontal format of the village. I must confess that the little track emanating from the very corner of the painting is an arrangement

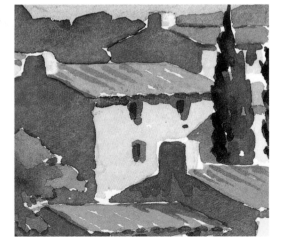

The warm grey shadows contrast with the sunlit walls to produce a three-dimensional effect

best avoided in the interests of good composition, but as it is not very prominent perhaps no great harm is done. The distant line of lavender-coloured hills provides an attractive backdrop and helps the sunlit walls to shine by contrast.

I was fortunate in finding some dense tree shade to work in, though even there the hot, dry atmosphere caused my washes to dry very quickly and require more water than usual. Working in dappled shade can play havoc with tone and colour evaluation and should be avoided at all costs.

Brush and ivory black

AVOID PAINTING WITH YOUR BOARD IN
FULL SUNLIGHT. IF NO SHADE IS AVAILABLE,
TURN YOUR BOARD SO THAT THE SUN FALLS
ON IT AT AN ACUTE ANGLE

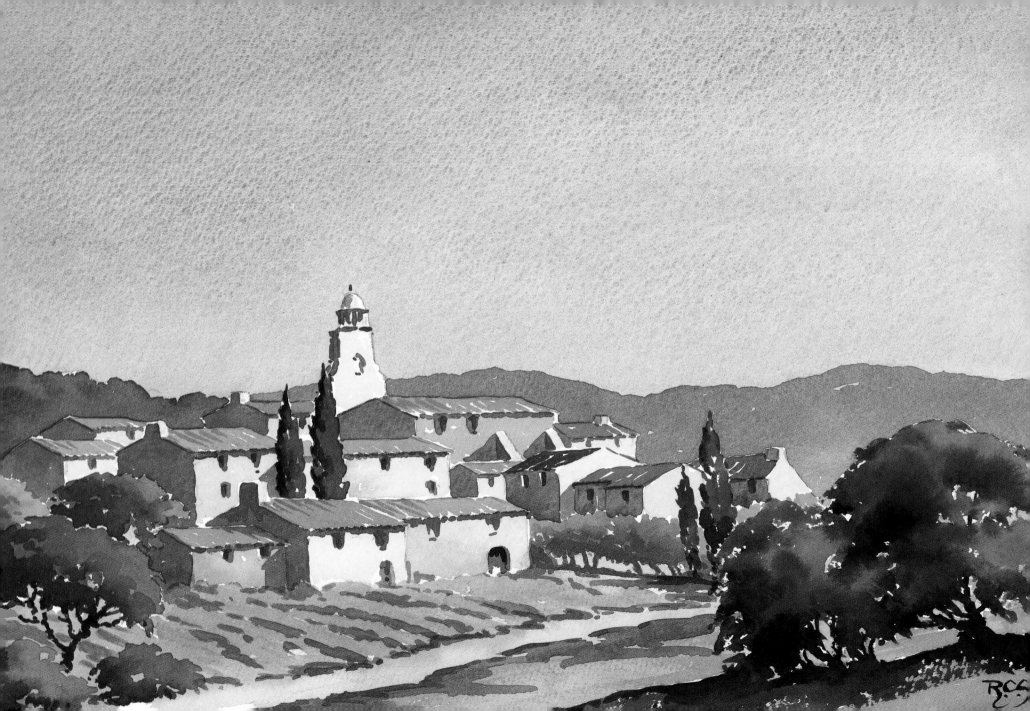

SANTORINI, GREECE

In very hot conditions the sun seems to drain much of the colour from the landscape, and we have to look very closely for those elusive tints. This applies even more strongly when white-washed walls figure prominently in the scene; but colour there is and it is up to us to find, and perhaps emphasise it. The walls of this church were, in fact, somewhat creamy in colour, but the blue of the cloudless sky was reflected strongly in the shadows and there were rich reflected lights in them too, which added both warmth and interest.

In a composition like this the shadows play an important part, not only for their colour but also for the manner in which they suggest the form and solidity of the buildings. This is a good example of a subject for which it is vital to choose the right time of day, when the shadows have most to contribute: a few hours earlier, and both elevations of the church were in full sunlight and shadows were almost non-existent.

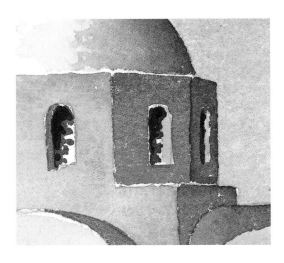

There is plenty of colour in the shadows and the half-shadows

Fibre-tip pen and wash

The sky is a variegated wash of french ultramarine with added light red and a touch of alizarin crimson towards the horizon, and I used fairly strong colour to make the sunlit walls shine by contrast. The shadows are mainly washes of french ultramarine and light red, to which I added burnt sienna for the warm reflected light. The dark green cypresses (Payne's grey and raw sienna) make strong vertical statements that contrast effectively with the pale-toned buildings.

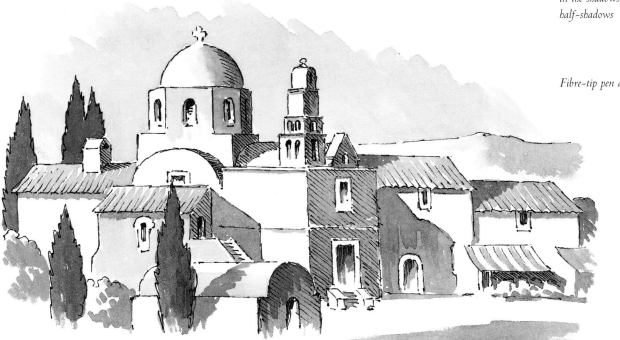

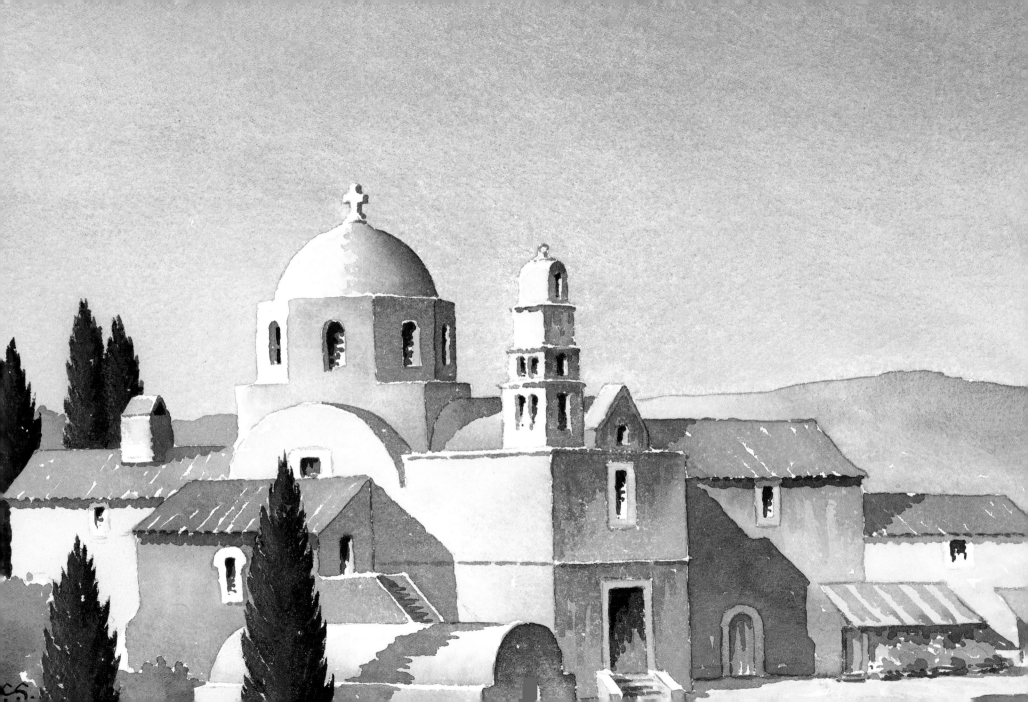

FLOWER MARKET, PROVENCE

PALETTE

RAW SIENNA
CADMIUM YELLOW
CADMIUM ORANGE
CADMIUM RED
ALIZARIN CRIMSON
BURNT SIENNA
LIGHT RED
FRENCH ULTRAMARINE
WINSOR BLUE

PAPER

ARCHES 300LB (640GSM)
ROUGH

BRUSHES

1IN (2.5CM) FLAT
NO.12, NO.8 AND NO.4
SABLES

This scene called for additions to my usual basic palette, notably the cadmiums – yellow, orange and red – and alizarin crimson. It was the riot of colour that first appealed to me, but I also liked the feeling of hot sunshine created by the strong shadows, particularly the deep shade under the awning on the left, against which the massed flowers and fruit registered most effectively. As the painting suggests, I found a spot which not only commanded the delightful street scene but afforded me shade from the hot sun. As we have already previously noted, painting in full sunlight should be avoided for it not only distorts one's perception of tone and colour but leads to difficulties with premature drying.

The composition worked well, with the roadway leading into the centre of the subject, the

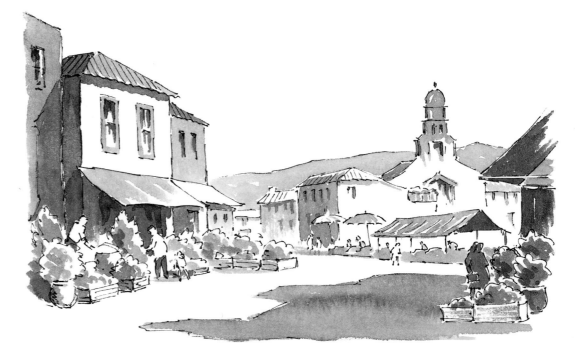

Fibre-tip pen and wash

For figures in the landscape, posture is more important than detail

objects on the left roughly balancing those on the right and with plenty of tonal contrasts in all parts of the painting. The simplicity of the sky – a variegated wash of french ultramarine merging into pale raw sienna – was a foil for the complexity of the scene, while the line of distant blue-grey hills contrasted with the warmer colours below.

The ochres and pale terracottas of the walls were mainly raw sienna and light red, and the cool shadows were a blend of french ultramarine and light red, with burnt sienna added for the warm

reflected light. The market was considerably more crowded than I have indicated, but I was anxious to do full justice to the colourful stalls and so drastically reduced the intervening throng.

A FEATURE OF THIS SCENE WAS THE
BRILLIANCE OF FLOWER COLOURS. MAKE
SURE YOU EMPHASISE THE SALIENT
FEATURES OF *YOUR* SUBJECTS

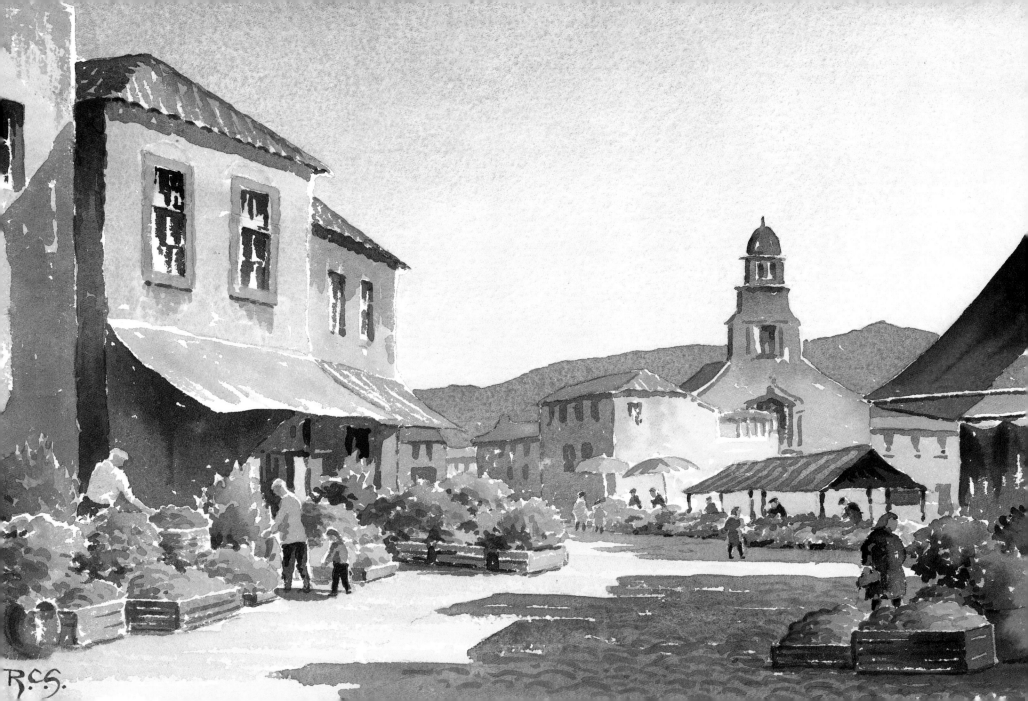

BALCONY ON CRETE

PALETTE

RAW SIENNA
CADMIUM YELLOW
BURNT SIENNA
LIGHT RED
FRENCH ULTRAMARINE
WINSOR BLUE

PAPER

ARCHES 300LB (632GSM)
ROUGH

BRUSHES

1IN (2.5CM) FLAT
NO.12, NO.8 AND NO.6
SABLES

This picture may look like an illustration for a holiday brochure, but it is a pleasant reminder of a most enjoyable painting trip to Crete. The many steps up the steep hillside to the villa were justified by the delightful view across the pantiled roofs to the sea and the blue-grey hills beyond, and by the welcome breeze which tempered the hot sun.

I made several preliminary sketches before I settled for this oblique arrangement of the foreground which I felt provided the best possible composition. In a sunlit subject such as this the shadows play an all-important part, not only in emphasising the brilliance of the light but also in giving the objects in the painting a feeling of solidity. As we have noted, timing is vital, for the treatment would have been less effective if all the walls had been in full sunlight, as they were a few hours later. It is the shadows, too, that produce the strong tonal contrasts – the white tablecloth, for example, against the shadowed balcony wall.

The sky was a variegated wash of french ultra-

The jumble of buildings against the sea is handled very simply

marine merging into pale green (Winsor blue and cadmium yellow), and the distant line of mountains french ultramarine with a touch of light red. I used the same blue-grey for the horizontal shadows on the pale ultramarine sea. The whitewashed walls were pale raw sienna, and their shadows, again, french ultramarine and light red. The sunlit tablecloth was just the white of the paper, which, being Arches, was slightly creamy in colour.

Fibre-tip pen and wash

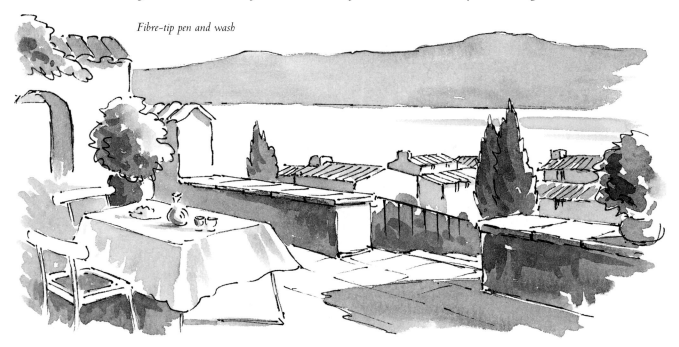

*H*ORIZONTAL LINES OF SHADOW ON THE
SEA CAN HELP THE SURFACE TO LIE FLAT

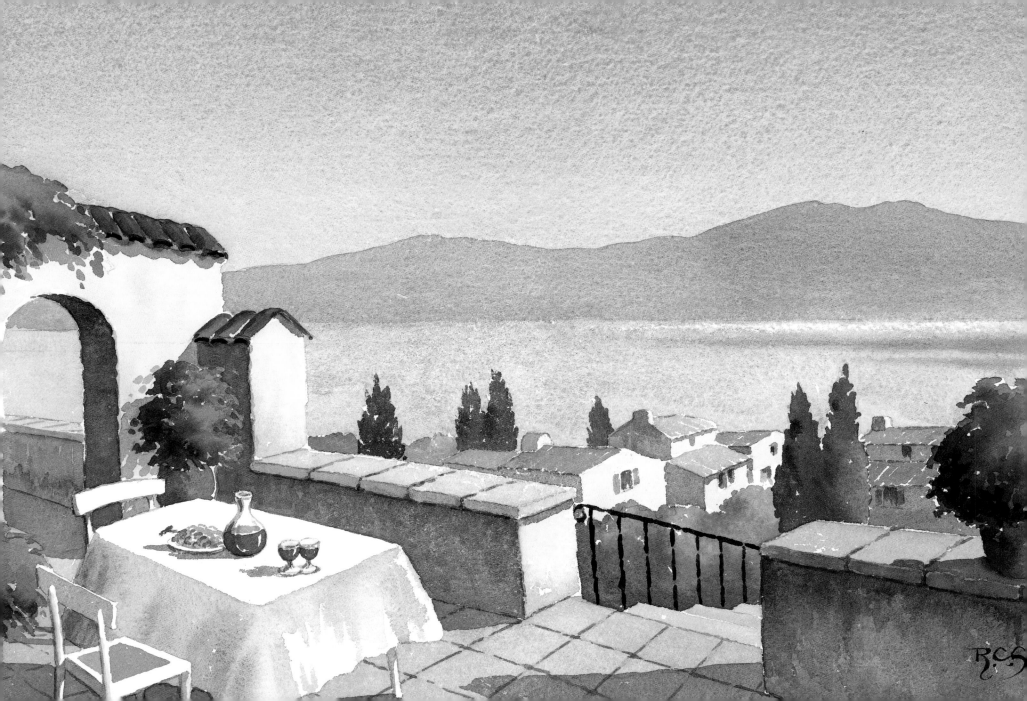

PALETTE

RAW SIENNA
CADMIUM YELLOW
CADMIUM ORANGE
BURNT SIENNA
LIGHT RED
FRENCH ULTRAMARINE
WINSOR BLUE

PAPER

ARCHES 300LB (640GSM)
ROUGH

BRUSHES

1IN (2.5CM) FLAT
NO.10, NO.8 AND NO.6
SABLES
NO.1 RIGGER

INNER HARBOUR

It is always a good plan to look for an original angle to your subject and not to be content with a conventional approach. I preferred this bird's-eye view to some of the ground-level sketches I had made because it revealed more of the complex jumble of pantiled roofs and resulted in an interesting composition with some strong diagonals. The position of the sun produced a pleasing mixture of sunlit and shadowed elevations and these helped me to achieve a three-dimensional effect. The late afternoon light brought out the warmth of the colour-washed walls and the terracotta tiles and I made the most of it.

An arrangement of this sort requires particularly careful attention to perspective, and if you have any difficulty in that direction it is well

Fibre-tip pen and wash

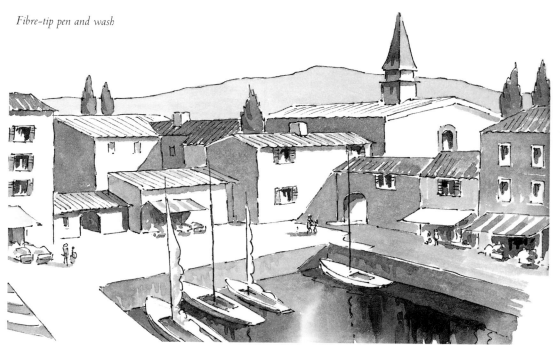

The brush strokes follow the slope of the roof

worth checking your drawing with the traditional constructions to make sure all is well. I sketched in the main lines on my watercolour paper with some care and then applied a wash of pale raw sienna to the sky area, adding a hint of french ultramarine towards the top. I used pale washes of light red and burnt sienna for the sunlit pantiles, making sure my brush strokes followed the slope of the roofs. I painted the line of distant hills with a fairly strong mixture of french ultramarine

and light red, against which the paler roofs stood out effectively. The shadowed walls were mainly french ultramarine and light red, with burnt sienna for the warm reflected lights.

> *ALWAYS BE ON THE LOOKOUT FOR INTERESTING VIEWPOINTS FROM WHICH TO CONSIDER YOUR SUBJECT*

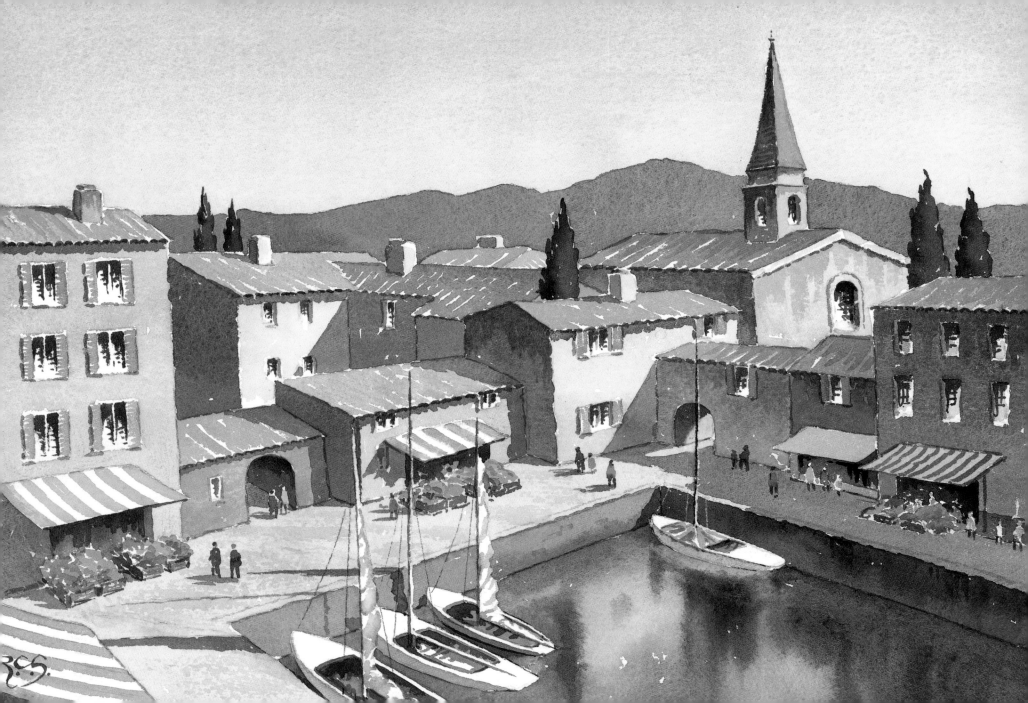

TOWN SQUARE, PROVENCE

PALETTE

RAW SIENNA
CADMIUM ORANGE
BURNT SIENNA
LIGHT RED
FRENCH ULTRAMARINE
WINSOR BLUE

PAPER

ARCHES 300LB (640GSM)
ROUGH

BRUSHES

1IN (2.5CM) FLAT
NO.12, NO.8 AND NO.4
SABLES

The buildings on the far side of the square are rather strung out in a straight line for perfect composition, but this was the only position from which the fountain could be seen against a shadowed background. Competing considerations of this sort often arise and those judged the most compelling have to be given preference. Here I wanted to feature the fountain and decided that it looked far more effective against a dark background, so that settled the matter. On the credit side, the line of buildings is interrupted by the two trees and also by the diagonal shadows which indicate that it is not an unbroken block.

This square is a pedestrian precinct so fortunately there were no cars to get in the way and I was able to choose the spot I wanted with no risk to life or limb. The light was coming from the left, and the cast shadows, as well as the figures, added interest to the foreground.

I indicated the few summery clouds by leaving some small irregular shapes of unpainted paper when applying a variegated wash for the sky (french ultramarine shading into raw sienna).

The fountain needed careful handling and I decided the best approach would be to leave some soft edges at the margin between the falling water and the dark background to suggest the misty spray and then add some pale, broken washes to indicate movement. I also had to break up the outline of the bronze fountain itself to represent the water falling in front of it.

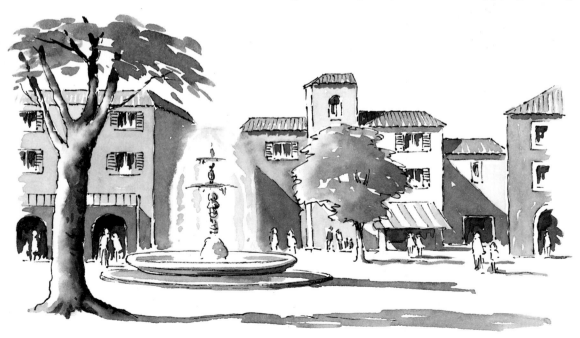

The awning, the tree, the figures and the shadows all help to break up the flat façade of the building behind

Fibre-tip pen and wash

W HEN TWO CONSIDERATIONS CONFLICT, A
VALUE JUDGEMENT HAS TO BE MADE AS TO
WHICH IS THE MORE IMPORTANT

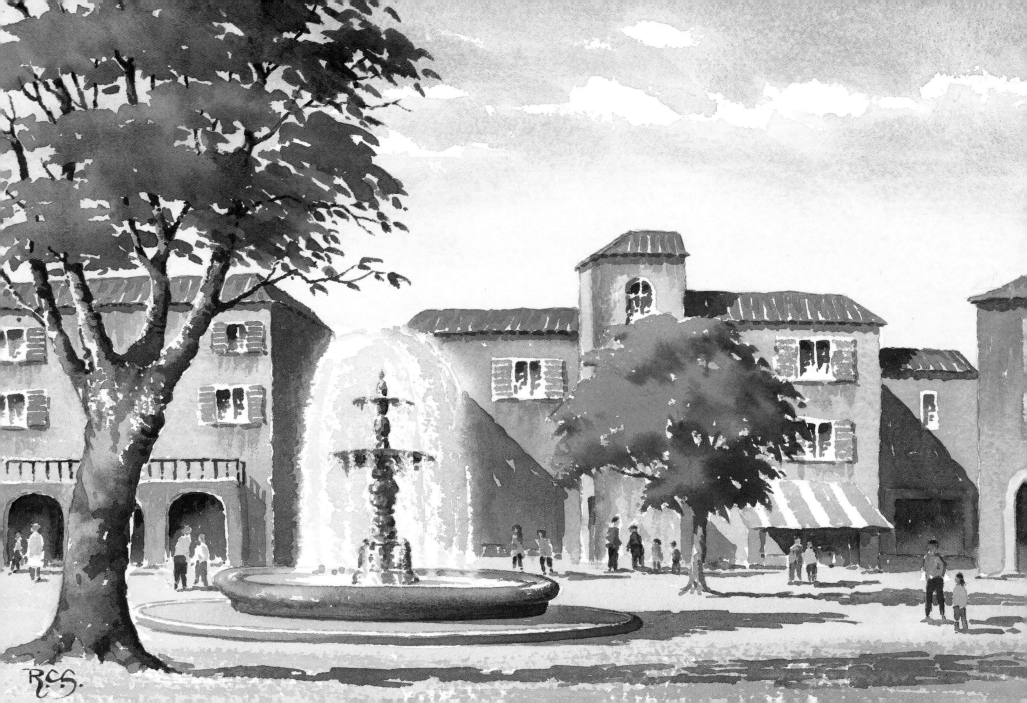

FORTIFIED VILLAGE, TUSCANY

PALETTE

RAW SIENNA
CADMIUM YELLOW
BURNT SIENNA
LIGHT RED
FRENCH ULTRAMARINE
WINSOR BLUE

PAPER

ARCHES 300LB (640GSM)
ROUGH

BRUSHES

1IN FLAT
NO.10, NO.8 AND NO.6
SABLES

The clustered buildings of hill villages make exciting subjects for the artist. Their random shapes are accentuated by the brilliant interplay of light and shade to produce strong, if complex, designs. When time is pressing I make as many sketches as possible, complete with colour notes, for future use, and then concentrate on just one or two finished paintings. Working in the studio, away from one's source of inspiration, is never quite the same as painting on the spot, but most artists have retentive memories for colour and form and, with the help of lively sketches, can recall the feeling of their subjects.

This scene had much to commend it. The pattern of the buildings was a pleasing one and was greatly strengthened by the effects of light and shade. The prominent church tower was balanced by the mountain mass to the right, to create compositional harmony. This tower constitutes a strong focal point and some of the construction lines lead the eye towards it – the outline of the mountain, the line of the river in the valley and

The distant river is just the untouched white of the paper

the stretch of low wall on the right. With a complex subject such as this it is particularly important to ensure the directions of all the cast shadows are consistent, for the sun may have moved appreciably by the time you have finished your sketch.

Do not be content with dull, grey shadows, but look for rich colours and reflected light effects.

Fibre-tip pen and wash

ALWAYS REMEMBER THAT YOUR PAINTING
WILL BE MORE AESTHETICALLY PLEASING IF
IT HAS A STRUCTURE OF GOOD DESIGN

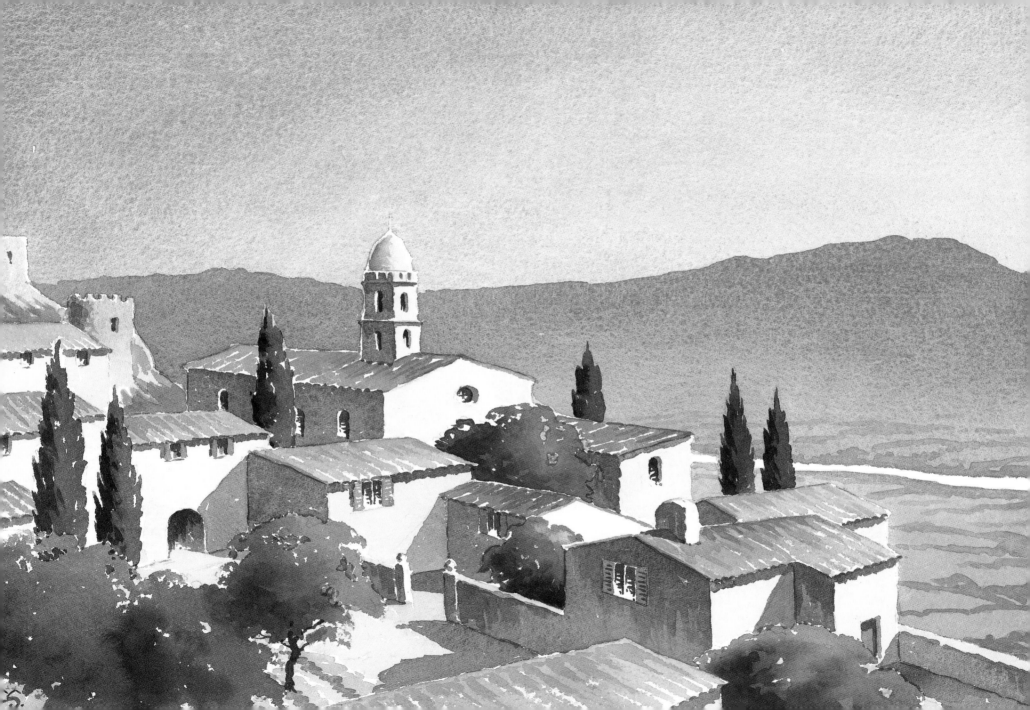

INDEX